Photographs by Lynn Saville Introduction by Arthur C. Danto The Monacelli Press

Night/Shift

The city at night

Let us go then, you and I,
When the evening is spread out against the sky
Like a patient etherized upon a table;
Let us go through certain half–deserted streets . . .

T.S. Eliot
"The Love Song of J. Alfred Prufrock"

For some years, Lynn Saville was a night photographer. Her images expressed the way that darkness transforms objects, rendering them almost abstract through submerging surface detail in favor of velvety black shapes, often set against the somewhat more luminous night sky. They were in effect nocturnes—night thoughts that turn what Hegel speaks of as "the prose of the world" into visual poetry. One had the thought that she must prefer the silent mysteries of the night world to the raucous, unforgiving light of day and took the risks of solitary explorations in darkness for the sake of its aesthetic rewards. The New York night world, as one knows from the photographs of Weegee, is full of violent incident. But Lynn's night world was of another order—and looked, from her photographs of it, like something softened by subtracting the light from things, like a magical translation, to use Shakespeare's language, into something rich and strange. Her book **Acquainted with the Night** was like a travel book, bringing to stay-at-homes images of a far country that she had made her own.

Night/Shift, as the unusual punctuation implies, marks an abrupt discontinuity in her work, in which the things are shown not in the harsh light of day, but without the benefit, one might say, of the natural cosmetic of darkness. This book addresses various sites in Greater New York, taken at the twilight hour through various seasons of the year. The sun has set, but its traces inflect the color of the sky, pinkish at the horizon, turning a luminous blue as one raises one's eyes, that subtly changes into a handsome translucent dark purple above that. The streetlights are on, patches of yellowish light fall across broken sidewalks, mostly empty, although the sites that attract this artist cannot at any time of day hold throngs. This is not the swanky New York of great stores and legendary restaurants. Rather, there is a feeling of run-downness, even of

abandonment. It is mostly the New York of film noir, of old-fashioned iron viaducts, fire escapes, garbage cans, tenement buildings, uninviting facades, graffiti, curtainless windows, heavy shadows, neighborhood barrooms with crooked neon signs that in these contexts suggest that strangers might better go elsewhere. Every American city with an industrial past has sites like these—bare ruined choirs where late the machinery rattled and hummed and workers with lunchboxes punched time clocks. What makes these distinctive of New York are the skylines and the great bridges that express the spirit the sites themselves expressed before they acquired the patina of abandonment and ruin. The city went on to find another identity for itself, and it even colonized its industrial endowment, turning leftover lofts into studios and ultimately into residential spaces, luxurious for their roominess and light. But the sites of interest to Lynn Saville are still unredeemed and rarely visited except by flaneurs like her, on aesthetic expeditions into the worn, the rejected, the forgotten, lonely, and dangerous remnants that no one but an artist with her sensibility knows what to do with, short of demolition. She captures them for the ashcan poetry of their desolation, against the day when someone puts them to more practical and certainly more profitable uses.

In many cases, of course, they are examples of the past-in-the-present, like the bridges and viaducts that are robust survivors, arteries for moving the city's relentless traffic. There are wonderful photographs of them, but as sites, not sights. No one visits the 125th Street viaduct the way, in Paris, they visit the Eiffel Tower, which belonged to the future when it was erected, but quickly enough lapsed into the period of wrought-iron architecture, lacy but beached by change. No one today would erect a bridge like the Brooklyn Bridge, which still has the dignity of constant use, but the architectural power of ancient arches. But for Saville it is a site, or background to a site, even

though it is also one of the great sights of the city for a different kind of project than hers.

Most of these are not sites many of us would have occasion to visit, not at this particular hour, when there is an air of menace. Lynn Saville must have a taste for urban danger, or she would not be there when those who may have a reason to be there in daylight hours have left for home. Behind the camera is a vulnerable body animated by an intrepid spirit, adjusting lenses, composing, capturing a squalid scene of weeds and rust where a cross street ends at one of the city's rivers. Overhead one of the city's great bridges—the Brooklyn Bridge, the Manhattan Bridge, the Williamsburg Bridge, the Queensborough Bridge—arches across our vision, casting light on the oily surface of passing water. There is scarcely a single place that evokes a desire to be there oneself, unless one shares the aesthetic of decay that drew the artist there. So she takes the risk a hunter takes, perhaps treating danger as a spice, but gaining the pleasure of having the site to herself. Just the thought of having to walk down a deserted street to reach the site makes one grateful to be home safe, turning the pages as her vision of this aging world unfolds. The city she is in search of is, after all, a kind of urban desert.

What we know is that these are threatened sites. Soon there will be cranes and bulldozers on these very spaces, condominiums will rise, as the city renews itself, and only such images as these will give us a sense of a phase of the city's history that is coming to an end, giving way to another, more gracious, less fearful phase, peopled by owners, doormen, dogwalkers, chic women climbing out of taxis—smart, undefeated New Yorkers, of another class altogether, different from those behind torn window shades, warming evening meals on greasy stoves in the last building on the street. For the present, this is old New York—broken, tired, squalid. Unlike with sights, sites of this sort will not give rise to preservationist groups, demonstrating against the wrecking ball.

In a city like this, such sites have disappearance as their destiny. Forget about it, someone would say. This ain't Penn Station. It ain't the Brooklyn Bridge. It's just the garbage of progress.

There is an affecting image of an empty elevated subway platform, titled Smith and Ninth Street—empty at least with the exception of her. It is a kind of spiritual self portrait. She has paid her fare, gone through the turnstile, climbed the metal stair to photograph, across the tracks, a facing platform, with a thinly distributed crowd of home-goers at the end of the workday. No one is going in the other direction. Typically of subway riders, these waiting passengers give each other plenty of space. They stand in sparse twos and threes, all along the platform, to maximize the chance of a seat to sink into after a long day. We are facing west, just after sundown under a beautiful evening sky, moonless and starless. There is only the acid glow of fluorescent bulbs, and a somewhat warmer light coming through the old-fashioned windows of the station house to our right. One thinks: tomorrow morning all those people will exit the trains onto this platform on which she, the photographer, stands, from which they will disperse to their various jobs. In a moment, the F or the G train will thunder to a stop. It is hard to believe that anyone will get off the train here, at this hour. When the train pulls out, the platform will be empty. Saville will have the whole subway stop, uptown and downtown, to herself, alone on an elevated structure that crosses the Gowanus Canal.

I have never been there in all my years as a New Yorker, but I tracked it down on a Google map. Most of the sites she discovered are like that. Who even knows where Hamilton Avenue is, or Basin Street, Sackett Street, or Kent Avenue? Everyone knows 42nd Street, but not the one she has found, with shuttered storefronts of vacated businesses, in which her shadow shares the street with a solitary pedestrian on some undisclosed mission. I have now and then crossed Gansevoort Street,

named after Herman Melville's grandfather, a fact that stuck in my memory from reading biographies of our great novelist. But what can one say of this large expanse of brick and worn asphalt at twilight? It is oddly empty of traffic, given its location close to the West Side Highway. Someone lives there, to judge from the bright lights with a truck parked in front of it. Its days are marked, as one must infer from the great apartment towers with views of the Hudson that have just been erected along the West Side Highway. Perhaps one is already under construction, and soon its fortunate tenants, holding cocktails, will point down at the thick traffic heading north to the George Washington Bridge or the Cross Bronx Expressway.

"It was so beautiful before!" Saville tells an interviewer doing a story about this book. "A sea of cobblestones—at dawn, when the light skimmed across the street, they seemed to undulate." One imagines she would have something equally vivid to say of many of the sites one happens to know— her reason for memorializing them now, before it is too late. But this is not, I think, a book of her favorite New York sites. It is an album of sites she has discovered, not part of the New York that constitutes her world—the constellations of places where she shops and works, and where her friends live, and where certain memorable moments took place. A friend once showed me his Berlin, which consisted of where he met the woman who became his wife, where they had their wedding party, where he lived as a student, and the like. The sites here are pictured more for their aesthetic of vacancy and ruin than because of their historical or personal associations.

Because of their characteristic emptiness, these sites remind me of the Paris of Atget. Atget recorded Paris in the early morning, before anyone was about. We feel his presence in the surrounding emptiness he has kept for the generations. Perhaps, if we looked for it, we could find his own shadow in one of the plates he left, cast by the rising sun, at an hour of the day when birds make their first tentative calls. Saville is his New York counterpart, the Atget of vanishing New York, prowling her city at the other end of the day, picking up pieces of the past in the present, just before it is swallowed by shadows. Atget, too, was not interested in sights. A sight is something that belongs on a tourist's itinerary. Grant's Tomb, for example, was a sight in the age of Henry James, a monument that tourists made a special effort to see. James felt that it embodied the democratic system, by contrast with the Invalides in Paris, where Napoleon is interred. Unlike the latter, there were no guards. Anyone could walk in. A short walk from Grant's Tomb is the great viaduct at 125th Street and Broadway. It is astonishing that there is no sign of life. It is the gateway to Harlem, and Harlem's residents can climb to the platform where the number 1 train runs up and down. She must have waited for the emptiness, to lend the site a feeling of uncanniness. For mostly it is part of the life of the neighborhood. Taxicabs are always making turns beneath it, coming in from La Guardia Airport. Students from Columbia or Union Theological patronize the inexpensive restaurants. It is, after all, dinnertime. And surely people are heading downtown to take in a show. Waiting, as one must do in New York if one is a photographer in pursuit of a certain feeling, is part of her craft. That twilight emptiness is the counterpart of darkness in her earlier oeuvre. It gives a sudden surreal aura to a site that could hardly otherwise be more real, and almost guarantees a feeling of déjà vu to places where one has never set foot.

Arthur C. Danto

Smith and Ninth Streets

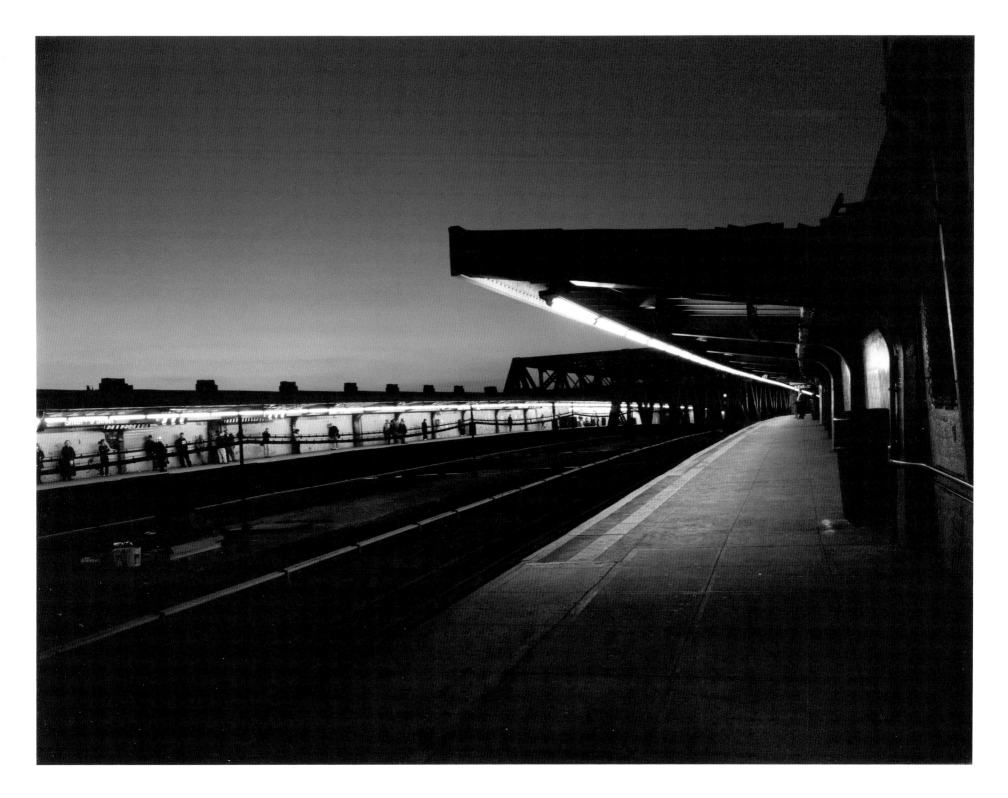

Trinity Church

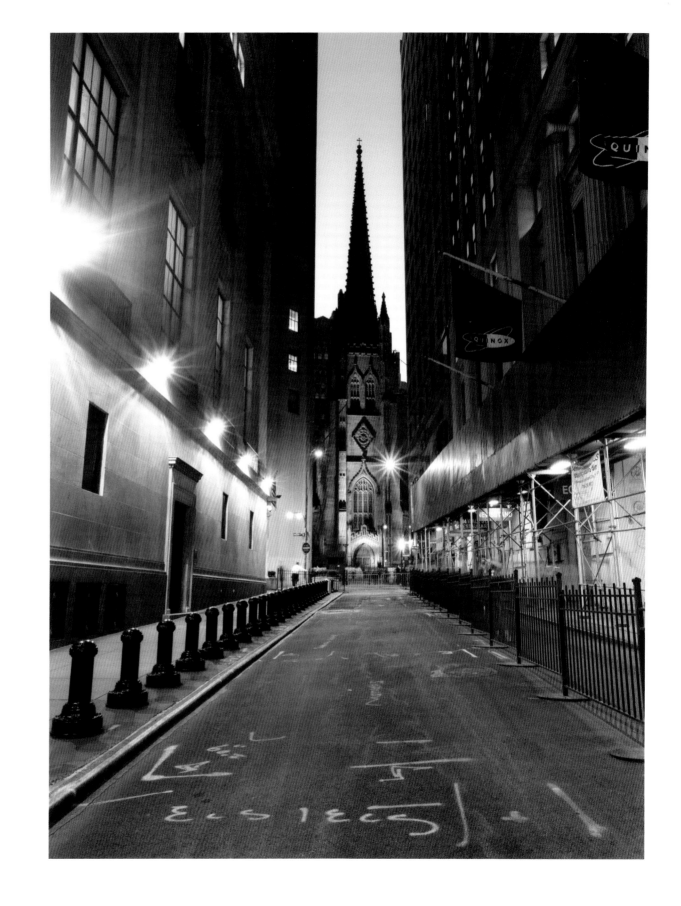

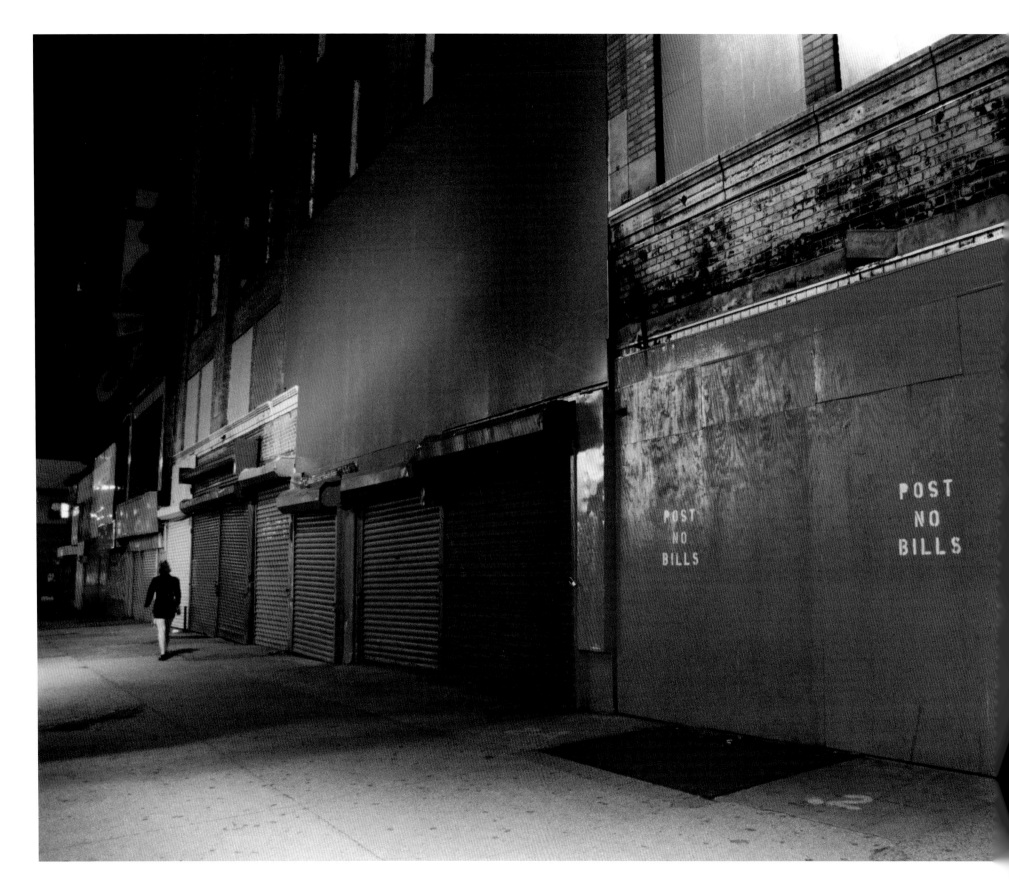

West 42nd Street

Dupont Street

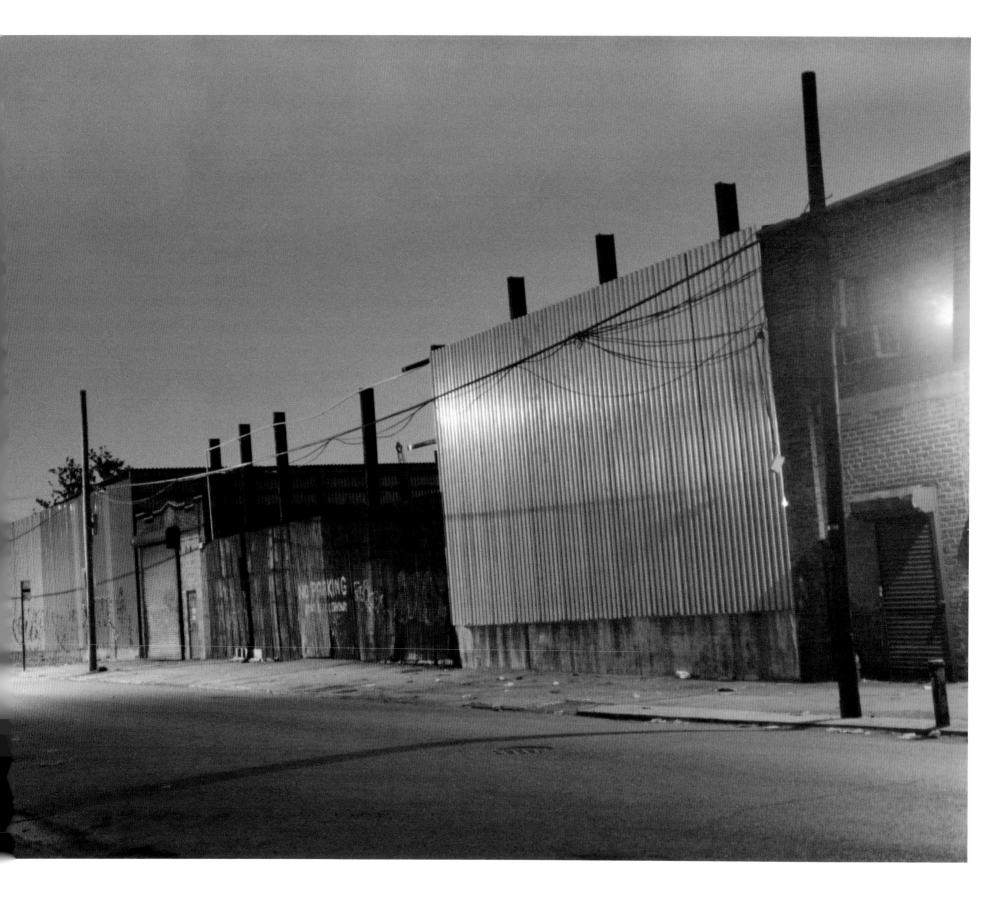

Main Street

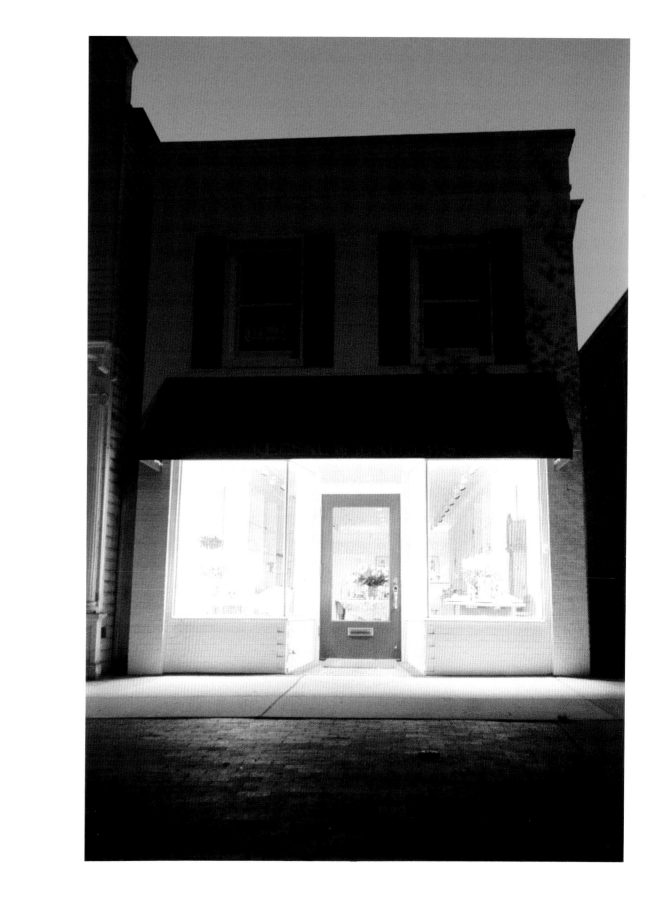

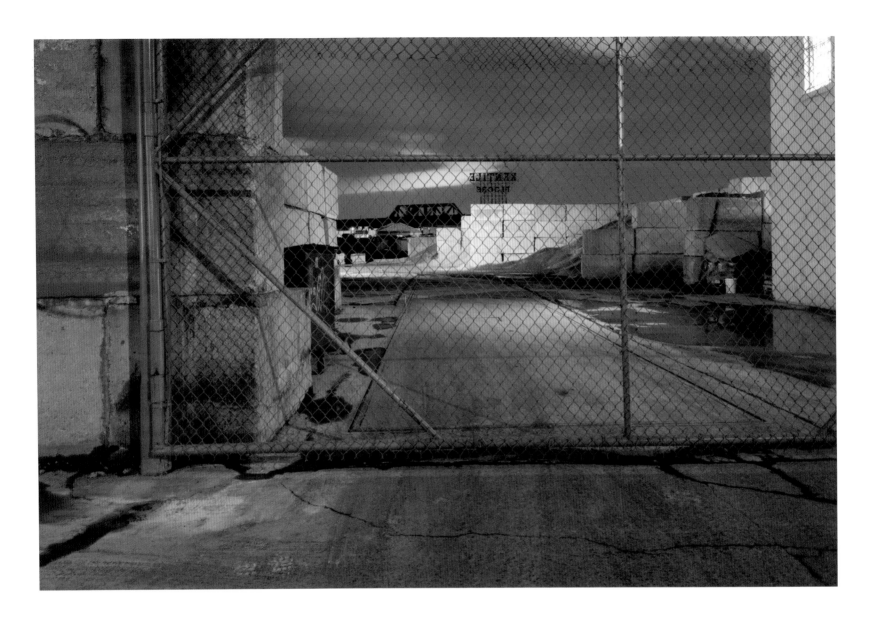

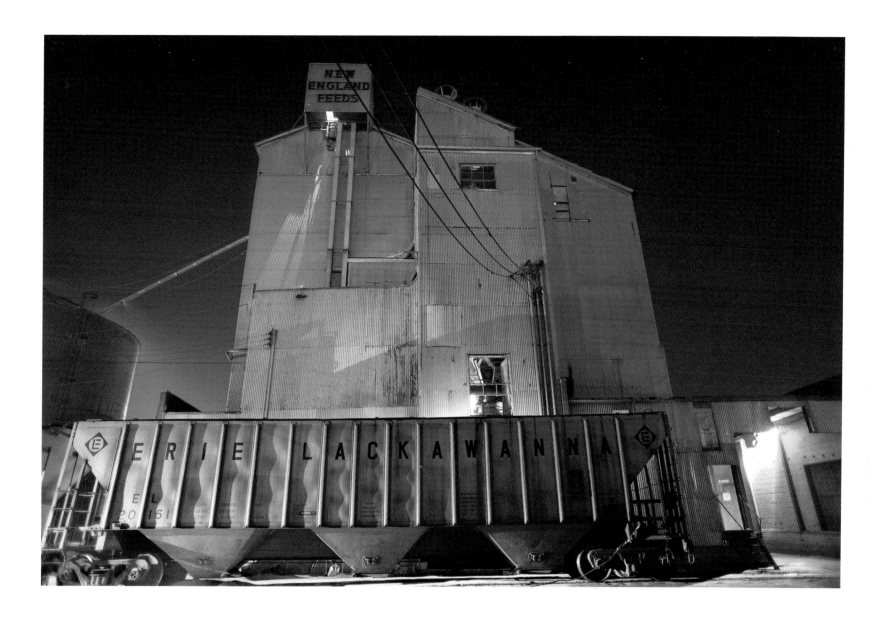

Kentile Floors
Railroad Yard

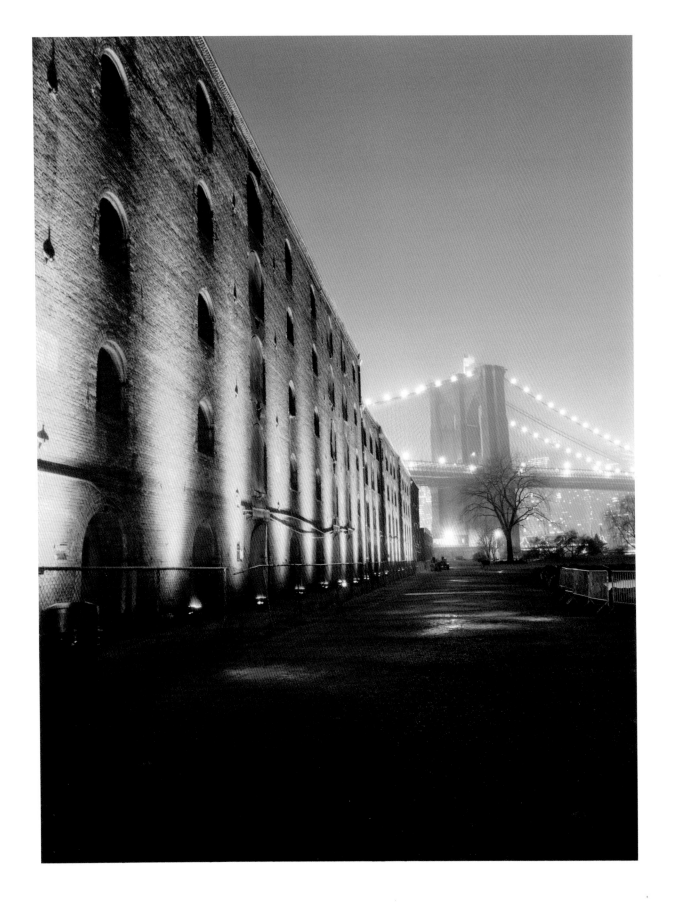

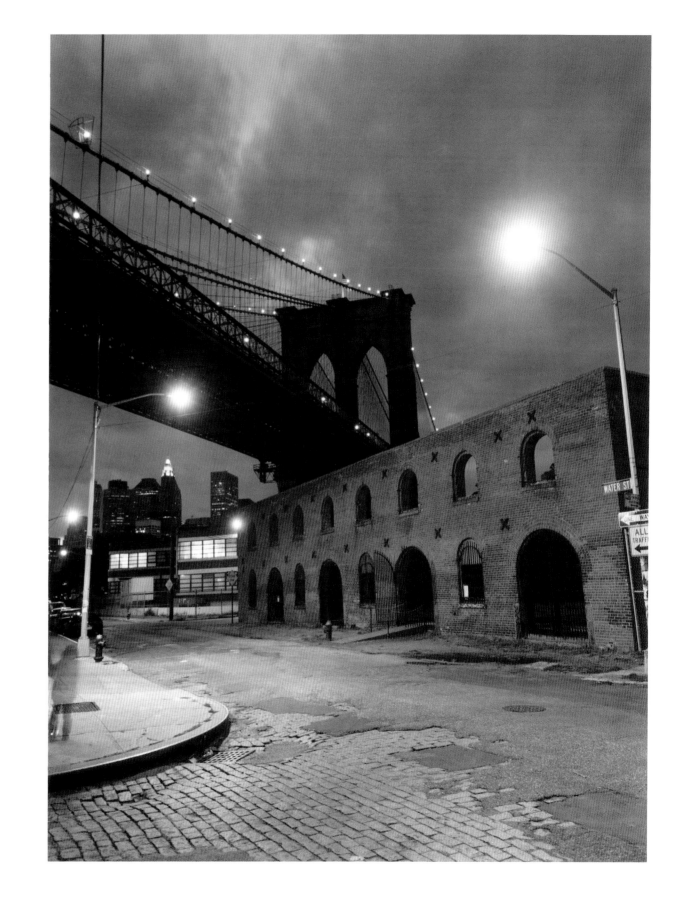

Brooklyn Bridge with Lighted Warehouse
Warehouse and Bridge

Fulton Landing Warehouse

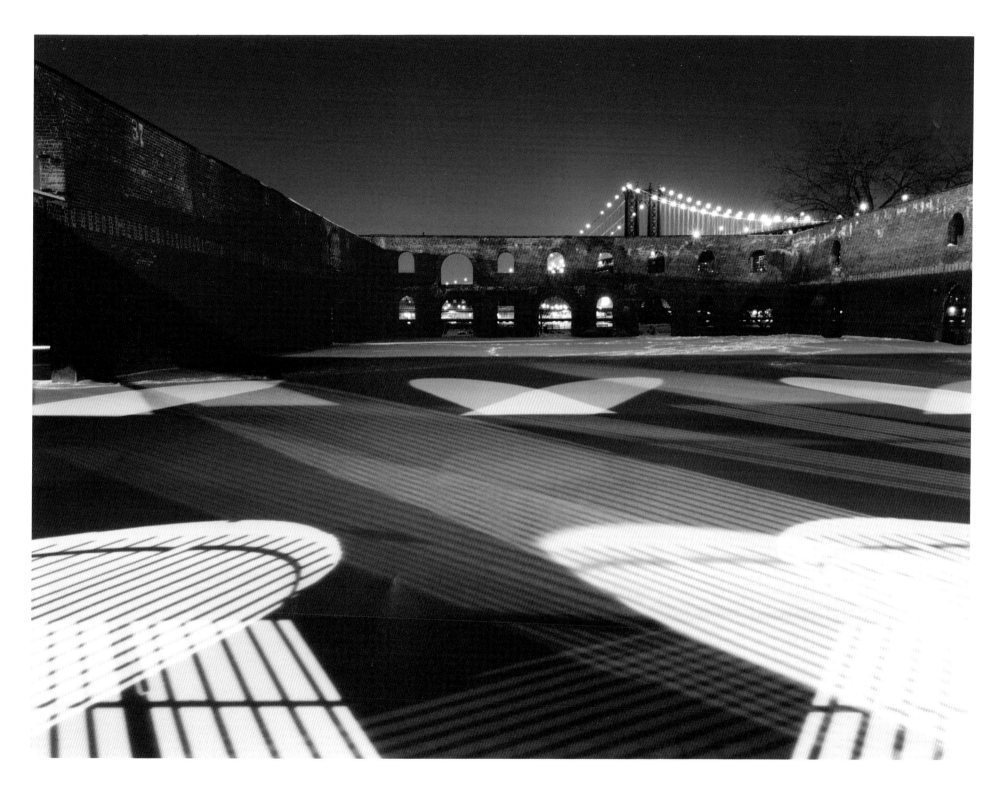

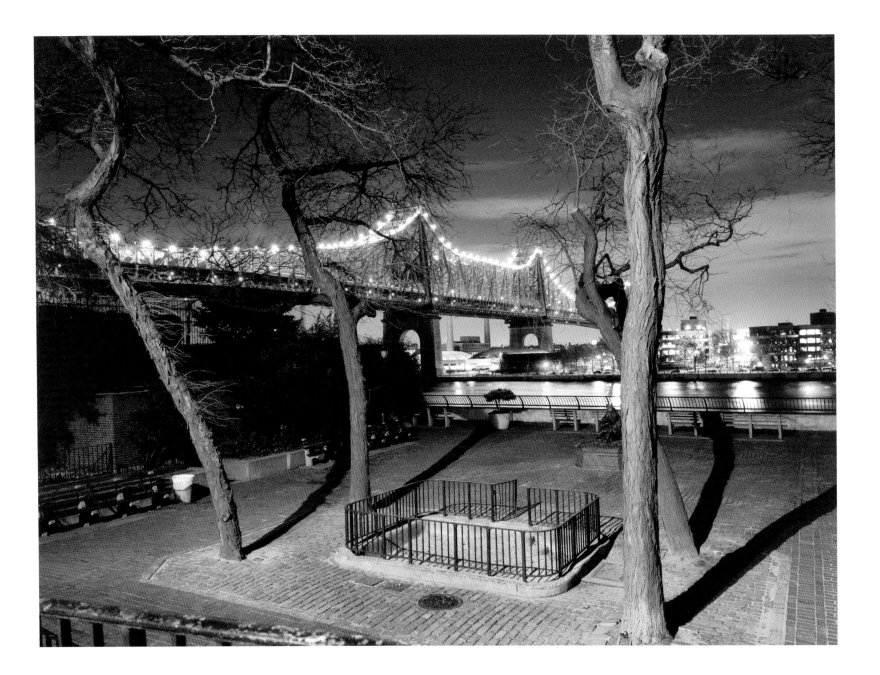

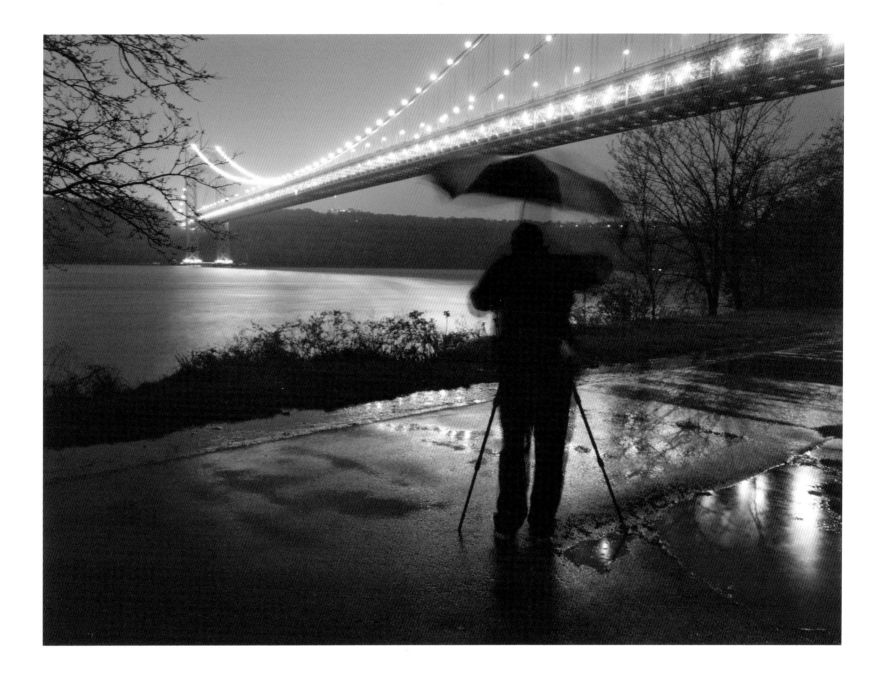

Sutton Place
Ken at George Washington Bridge

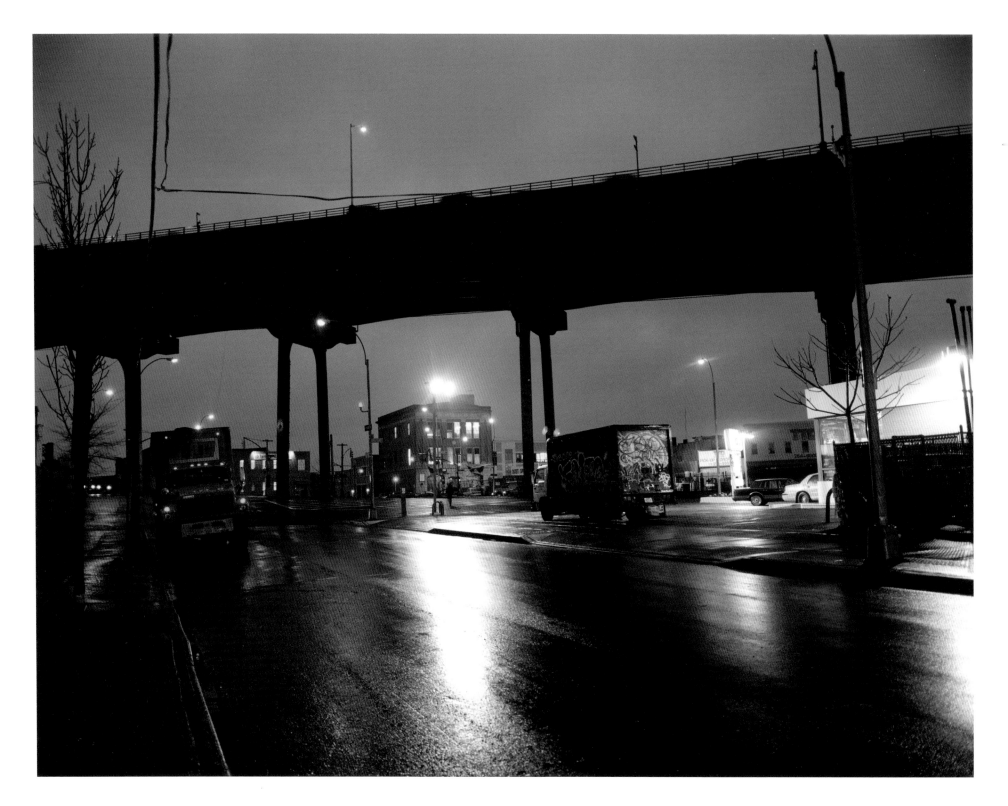

Hamilton Avenue

Basin Street

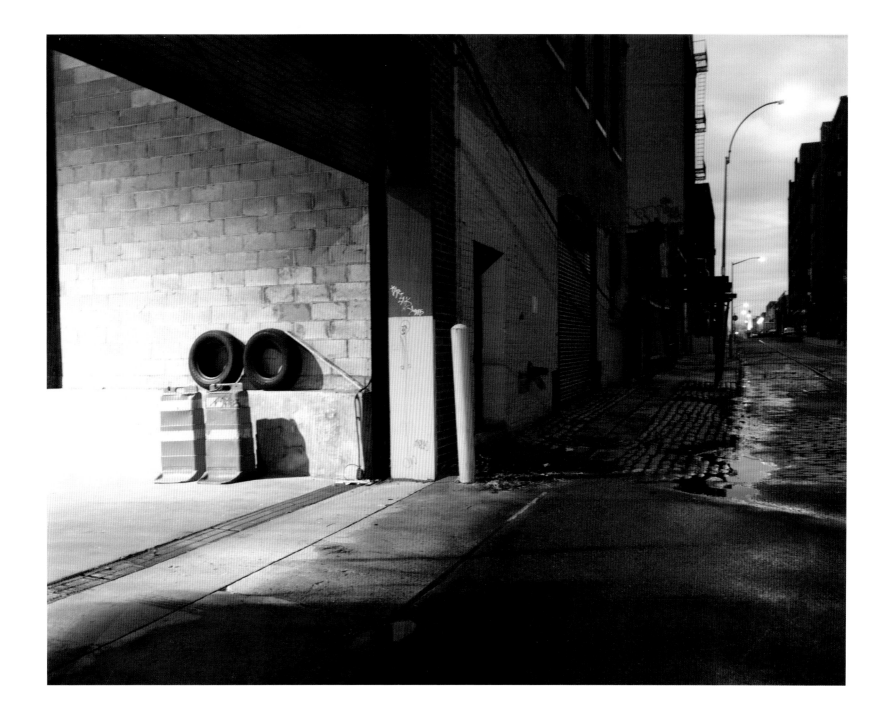

Star on Adams Street

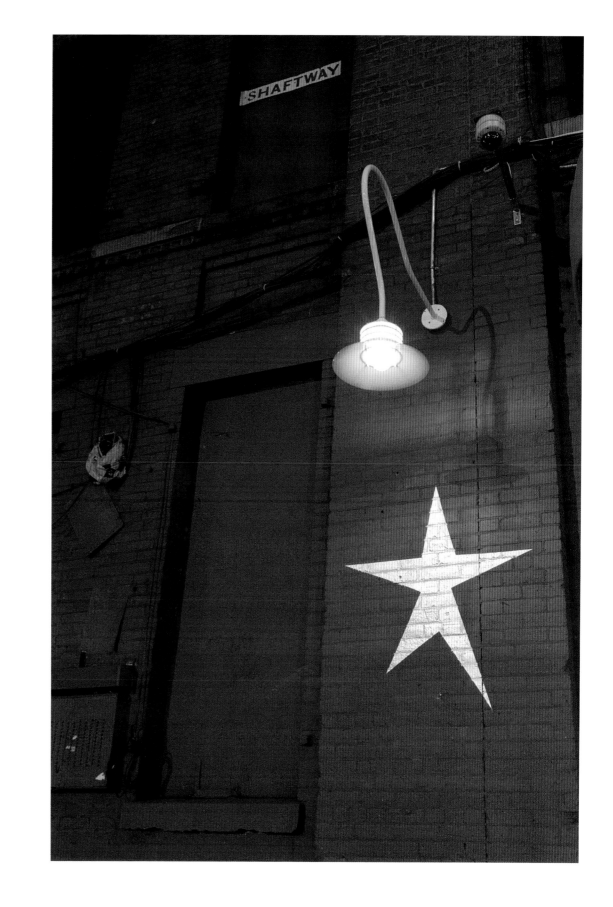

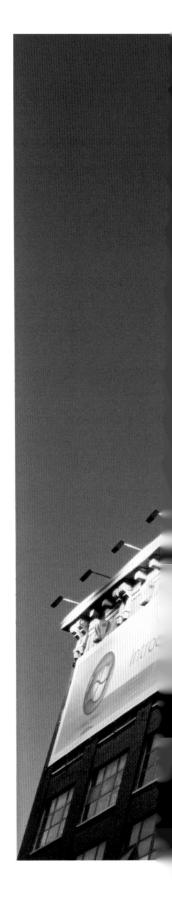

Long Island City

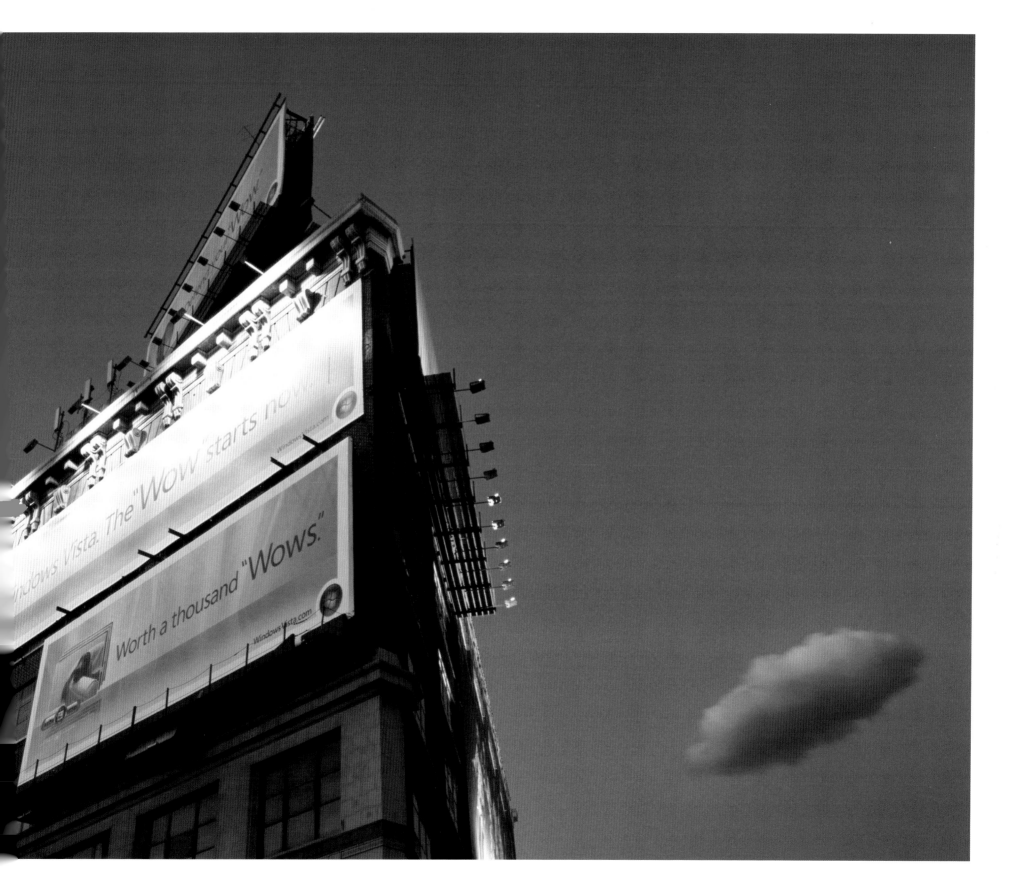

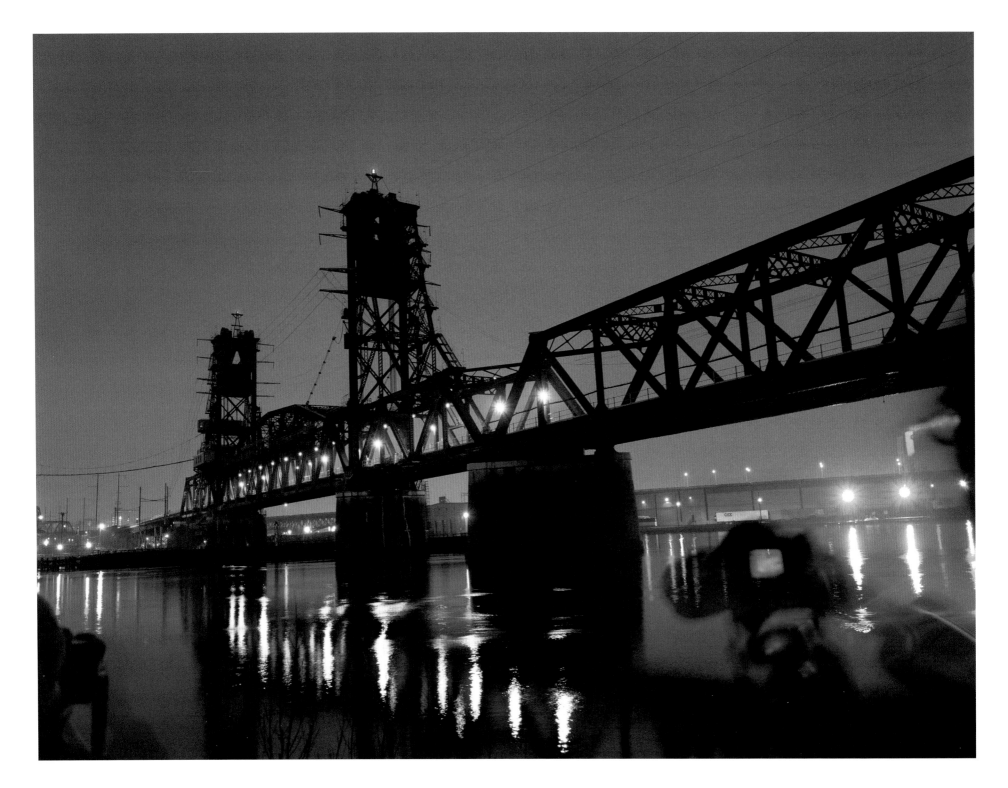

Students at Hackensack Bridge

West 125th Street

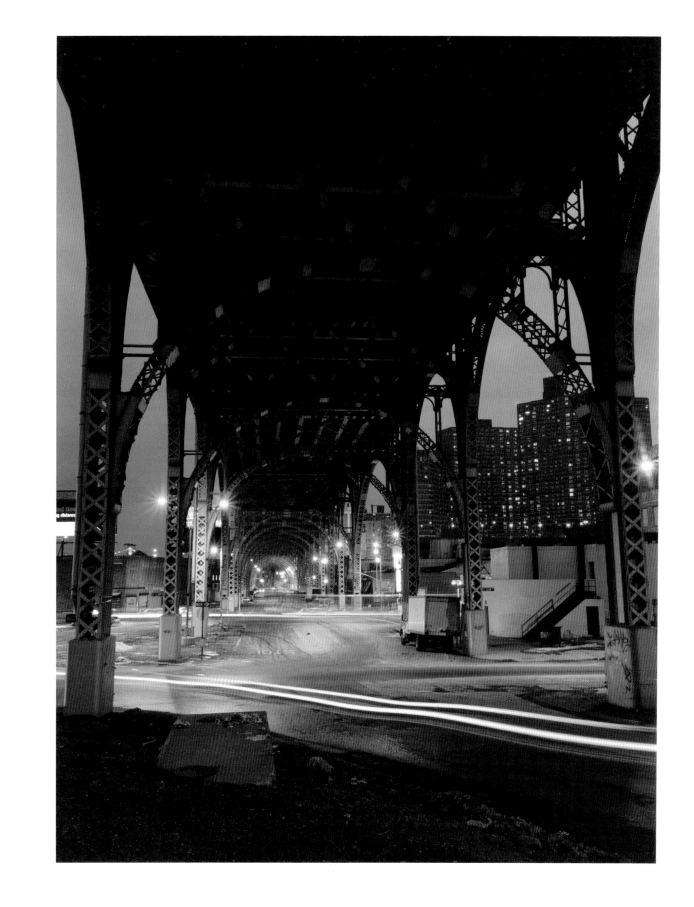

Coney Island Avenue

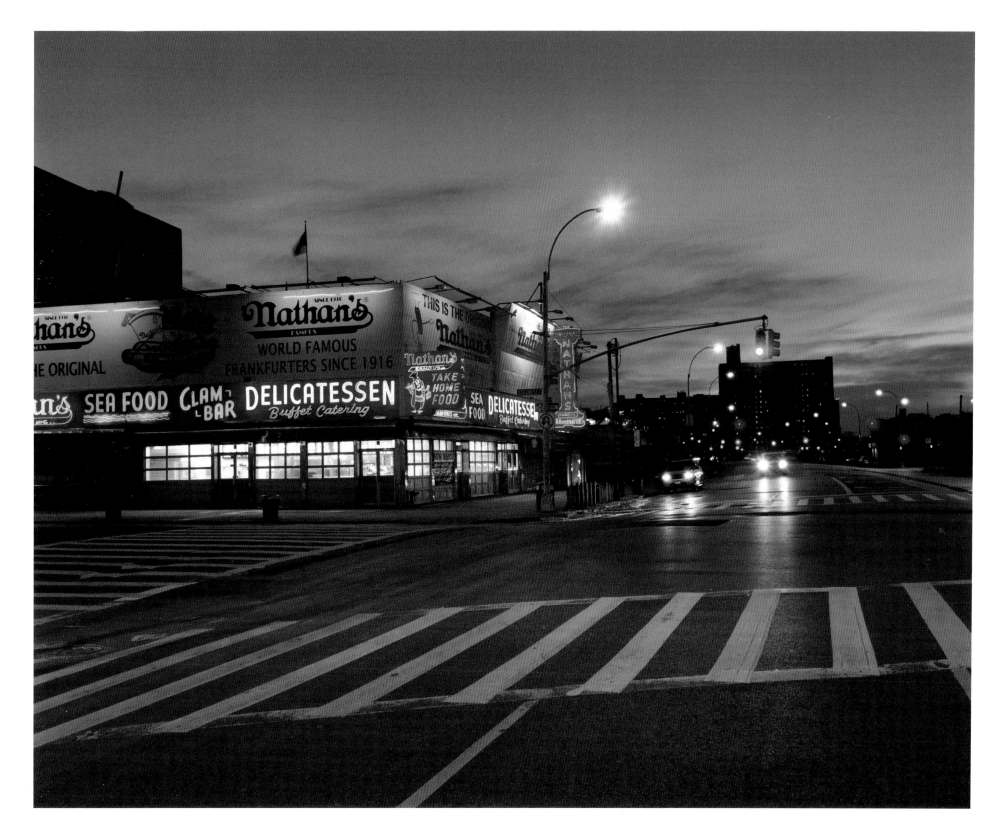

East Village

712 West 125th Street

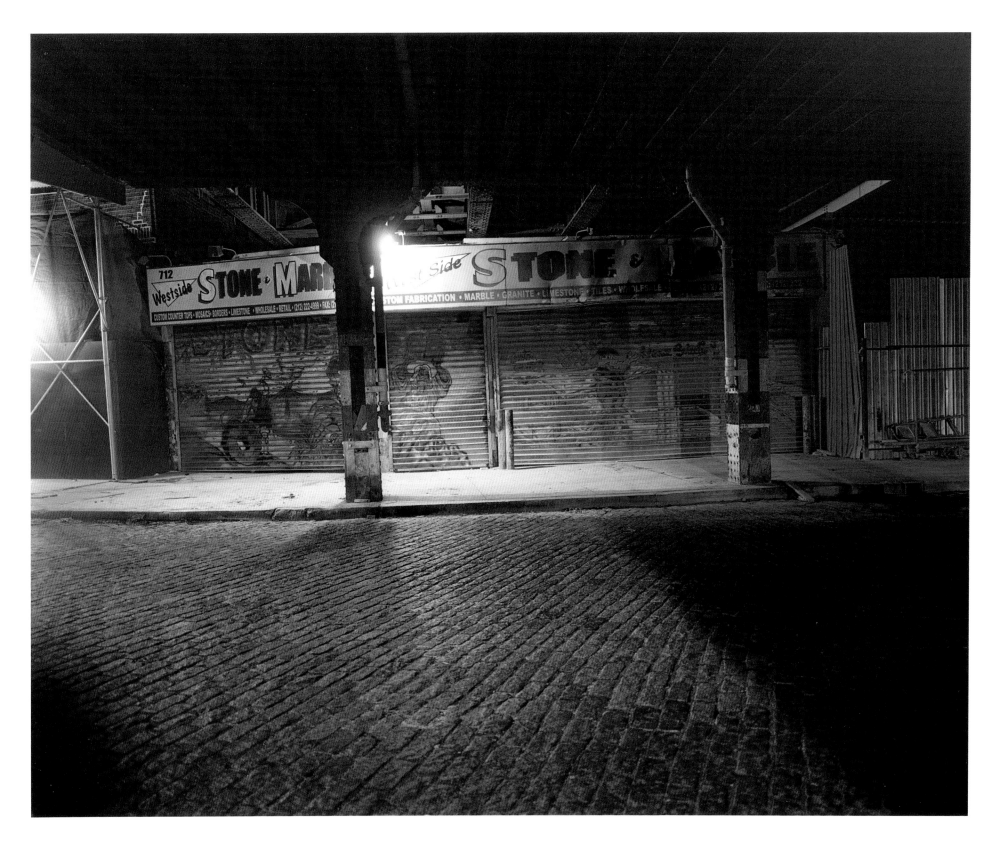

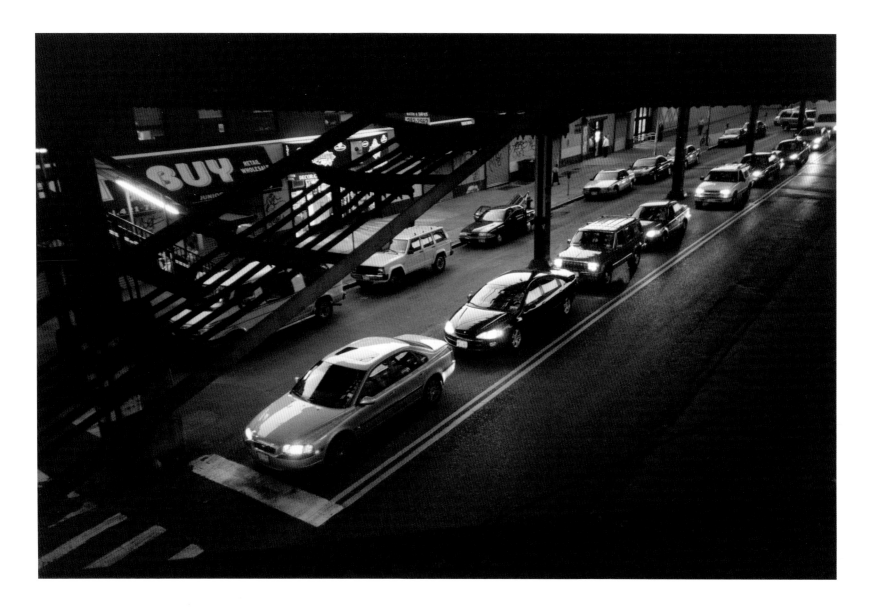

Surf Avenue, Brighton Beach
Tenth Avenue

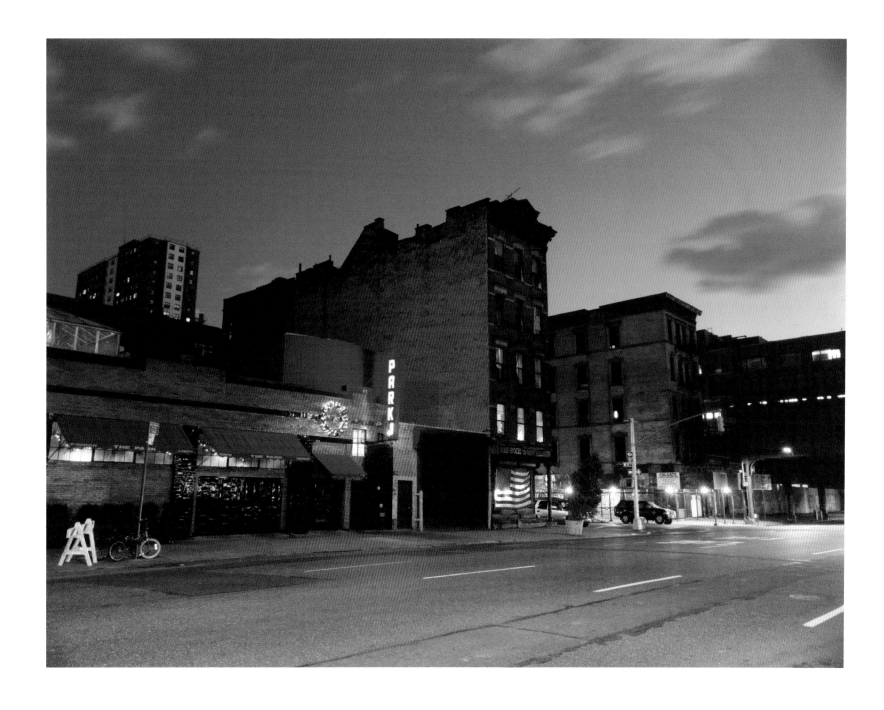

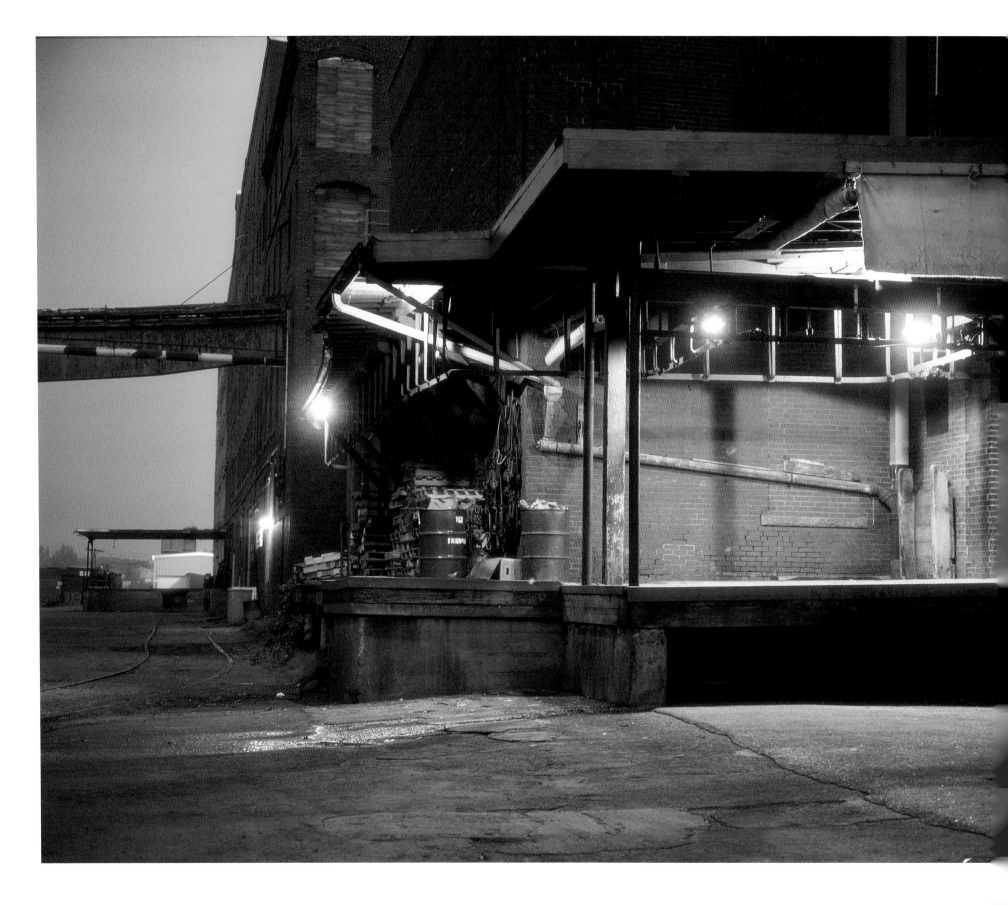

Loading Dock

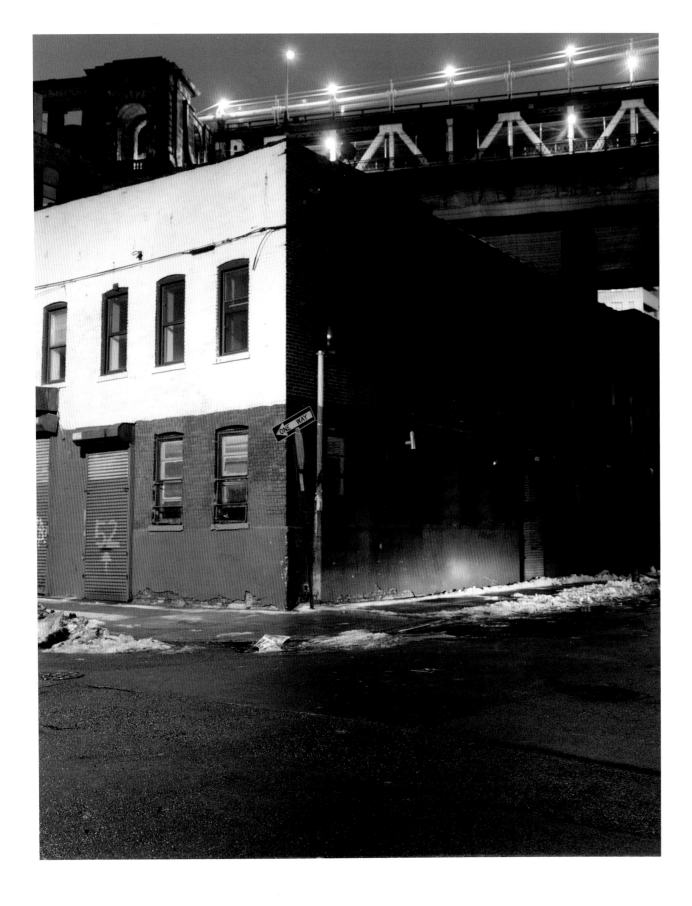

Water Street
West 17th Street

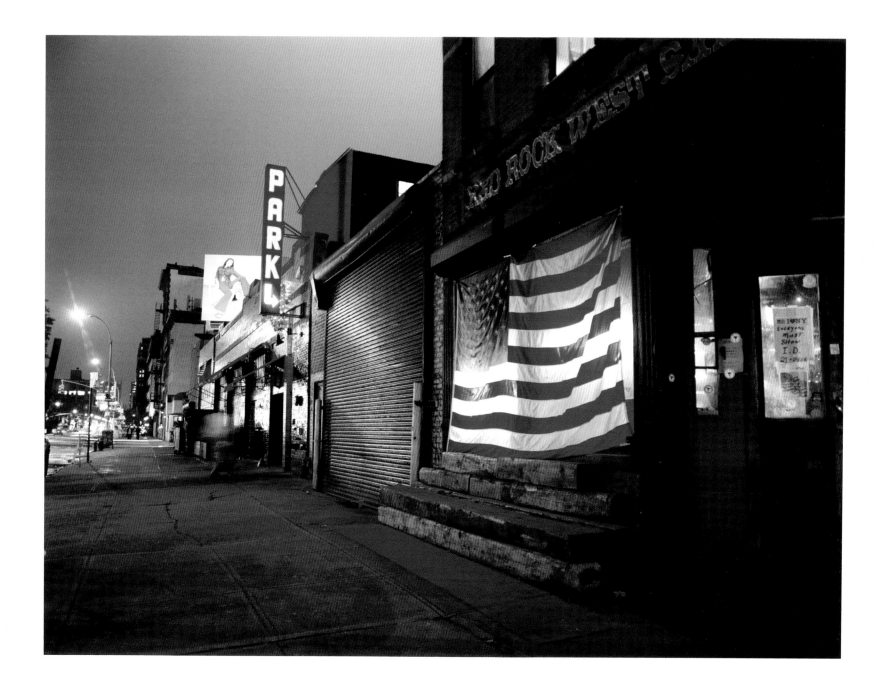

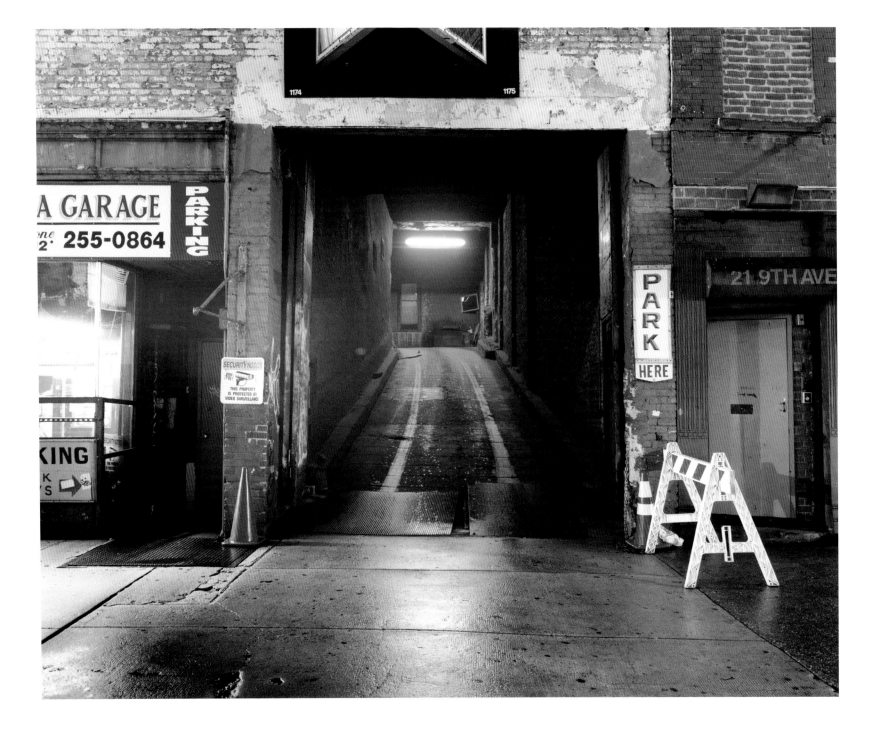

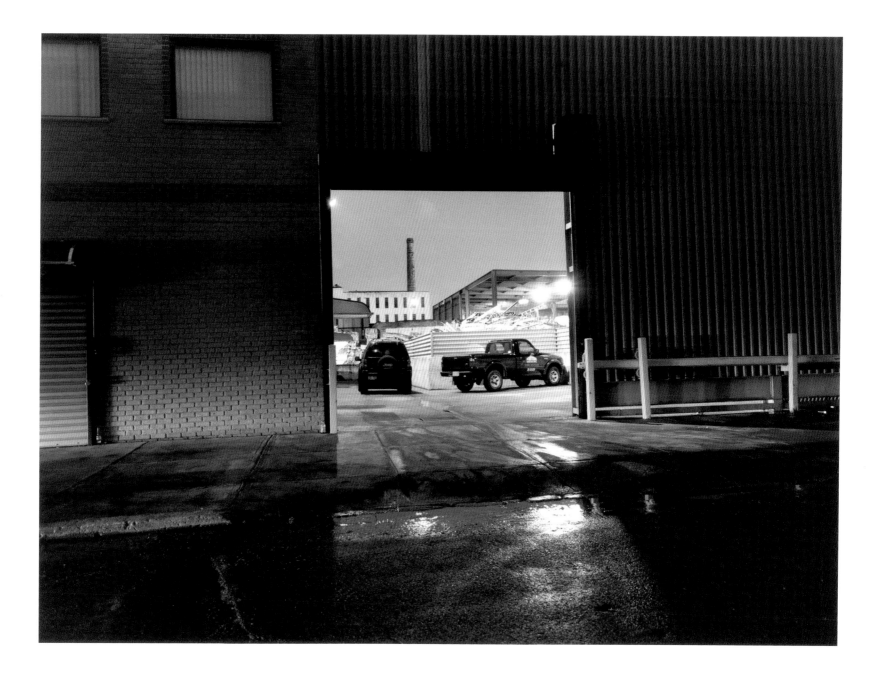

Ninth Avenue
Huron Street

39 Washington Street

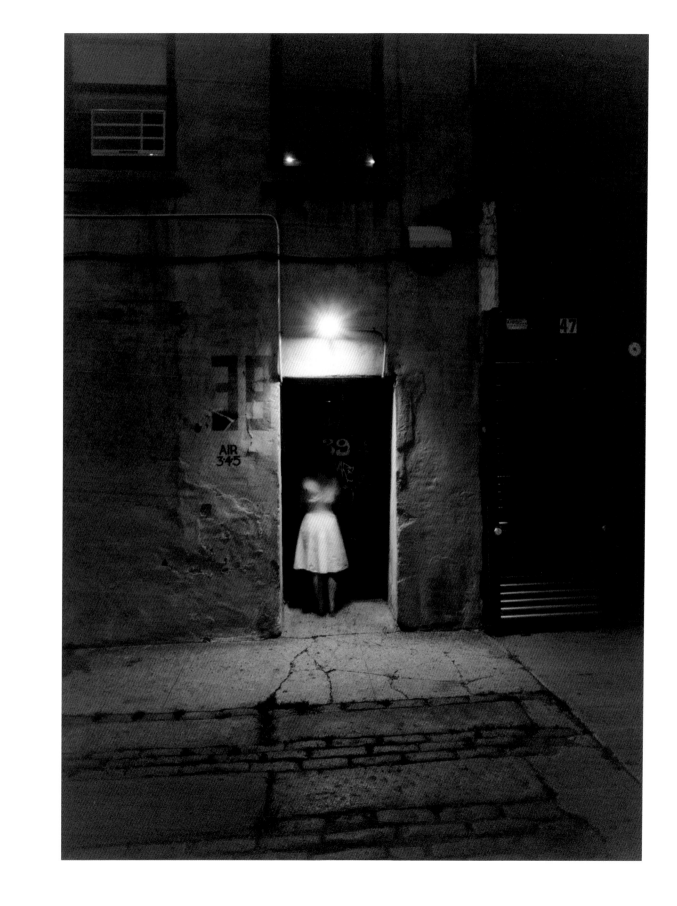

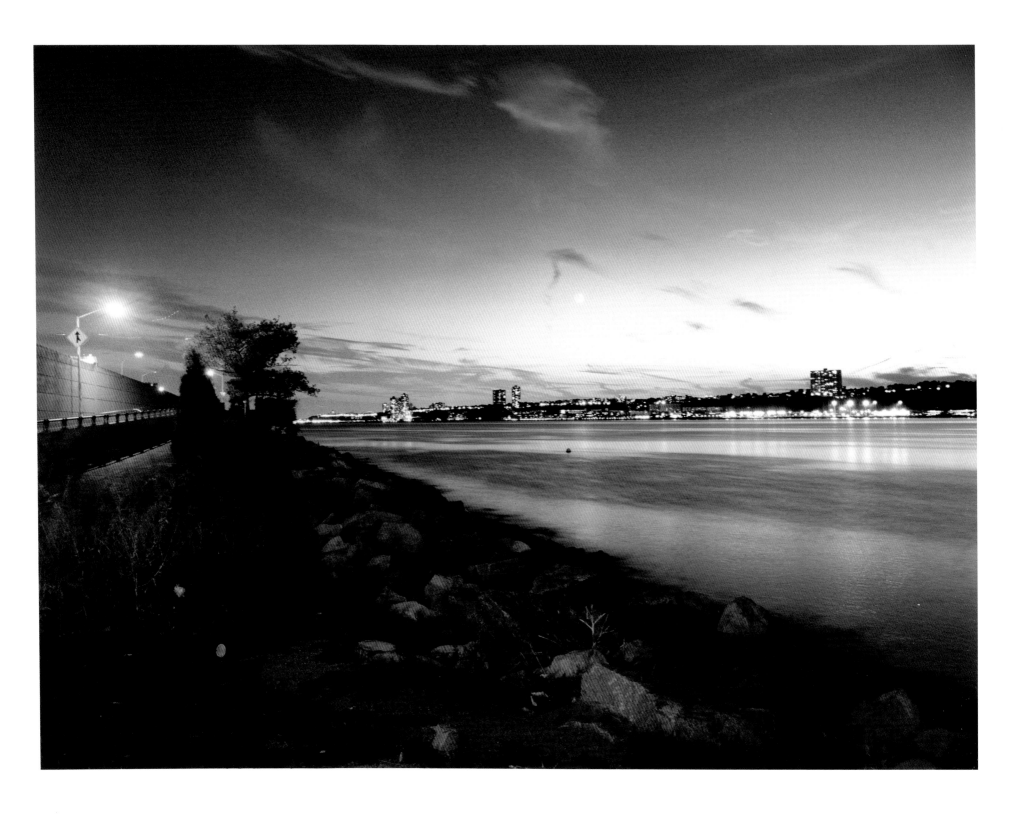

Westside Highway and Hudson River

Pepsi-Cola Sign

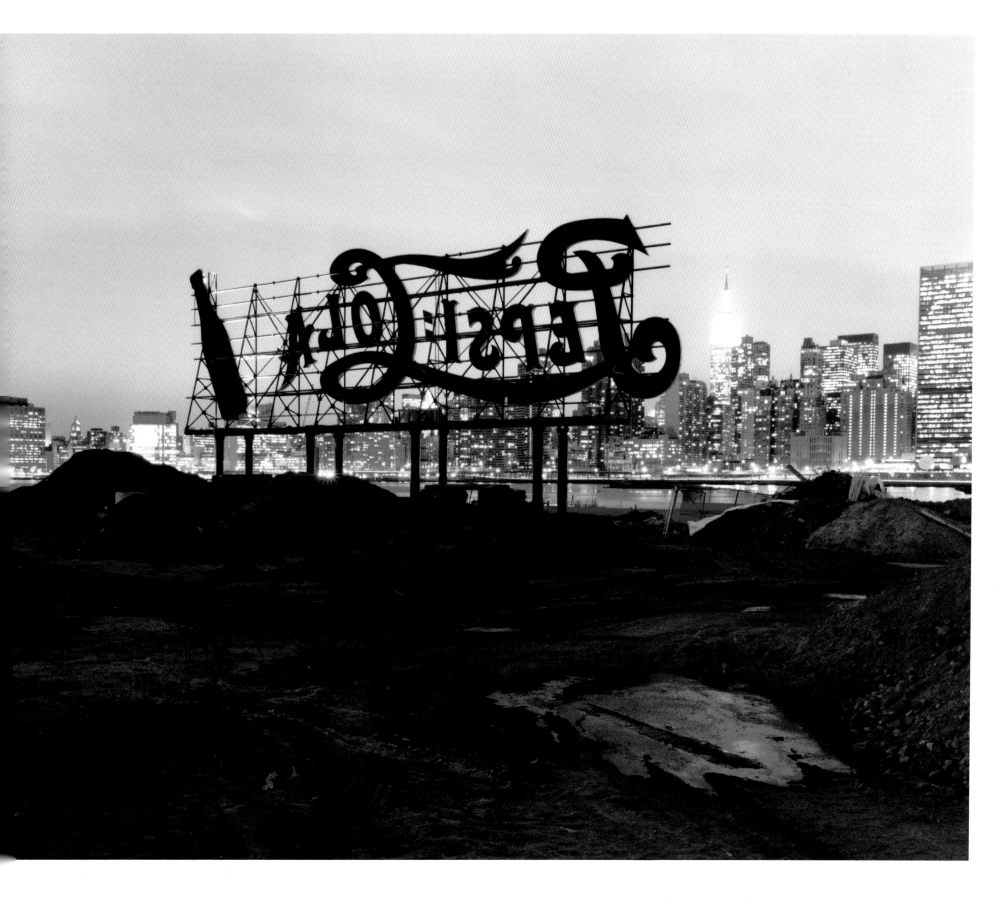

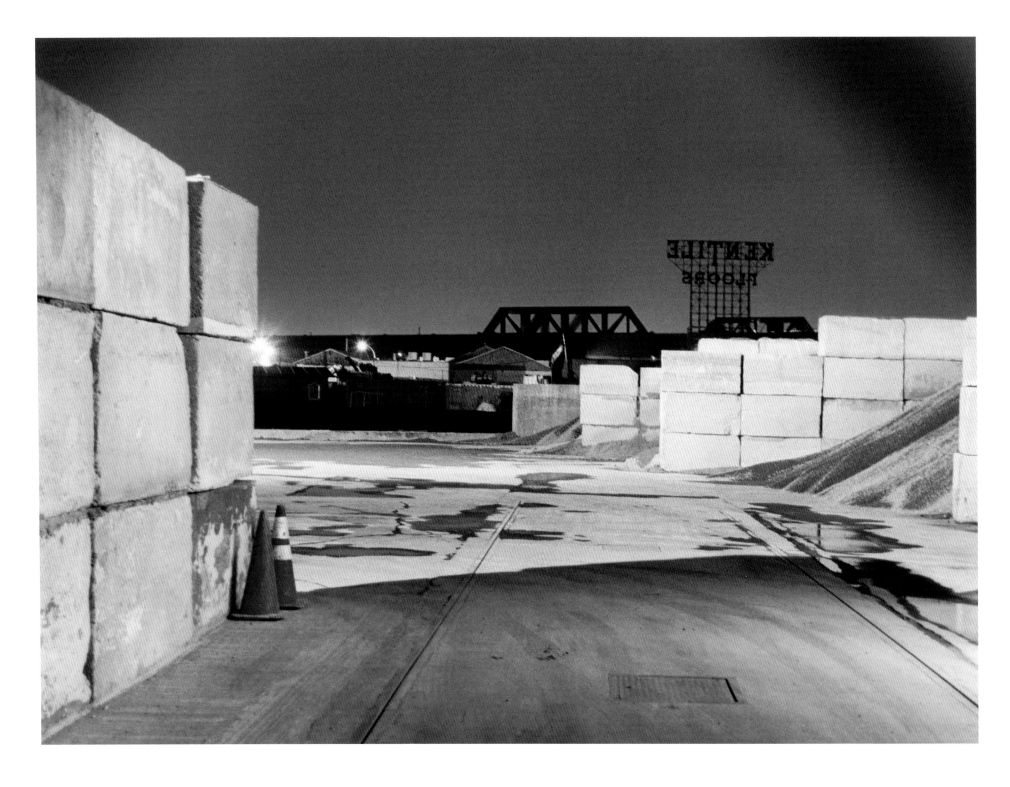

Third Street, Brooklyn

Gowanus Canal

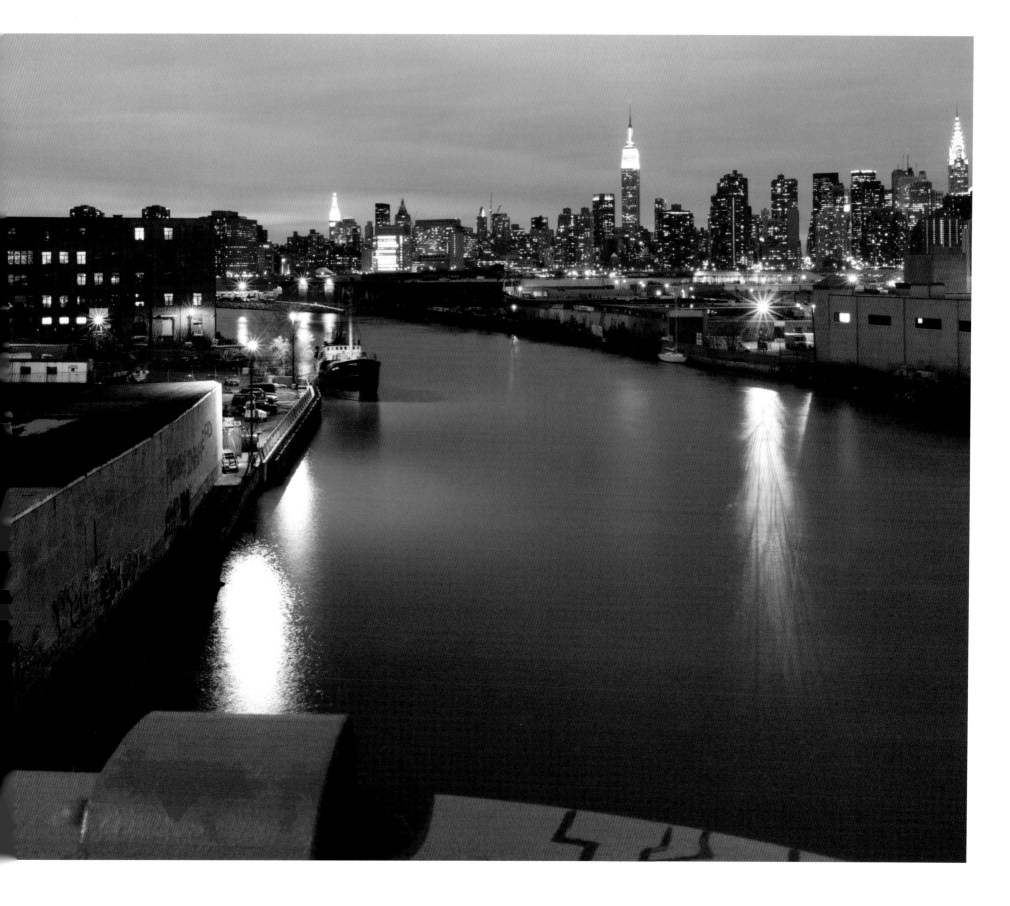

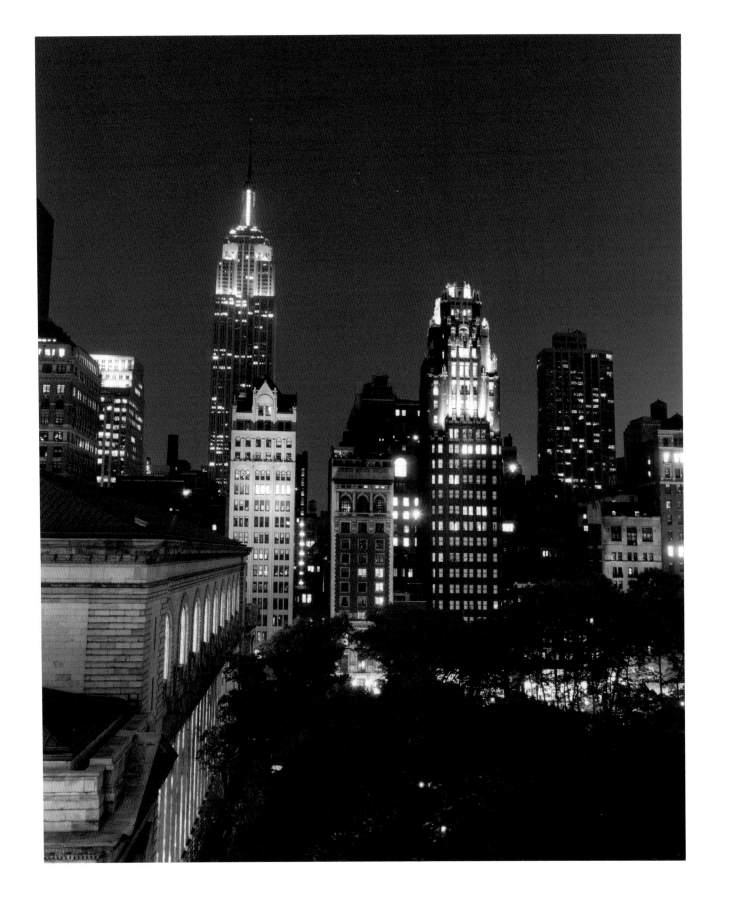

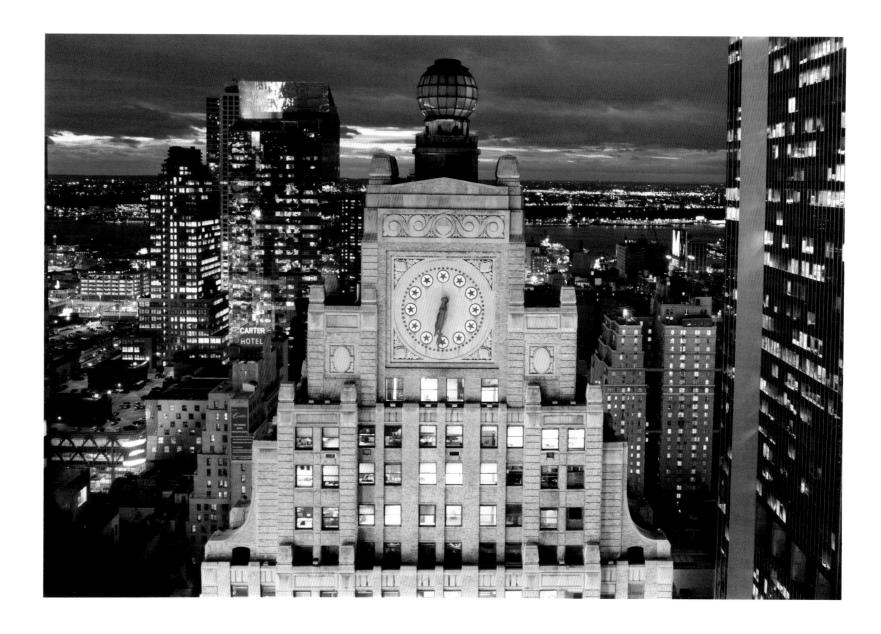

Bryant Park Looking South
Paramount Building

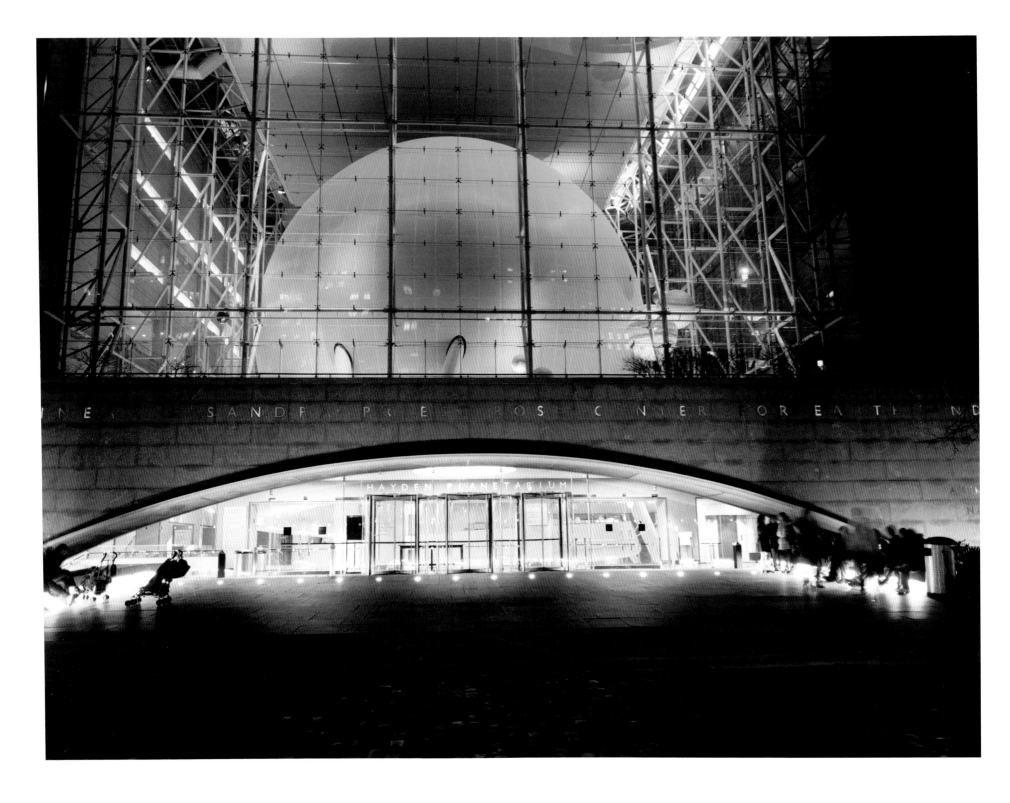

Rose Center
Lower East Side

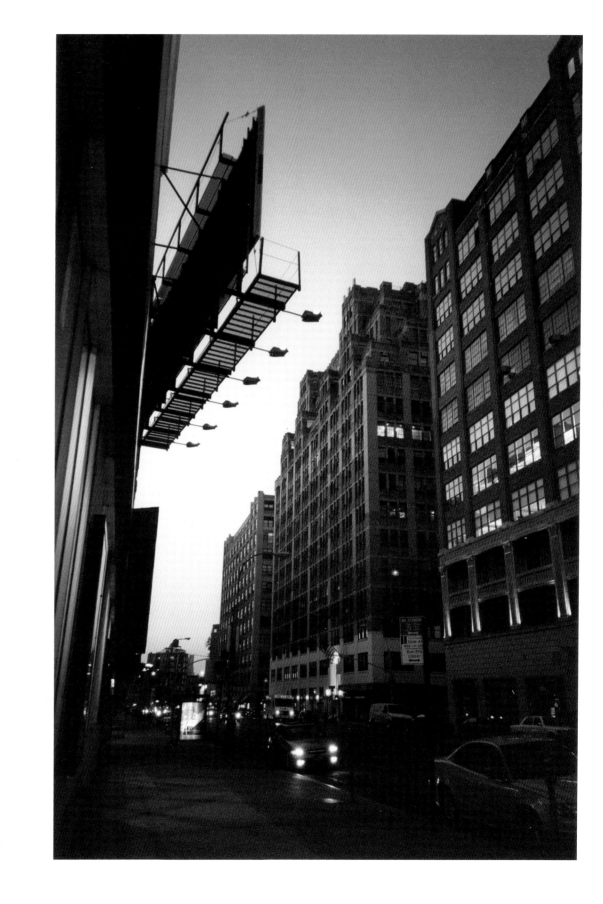

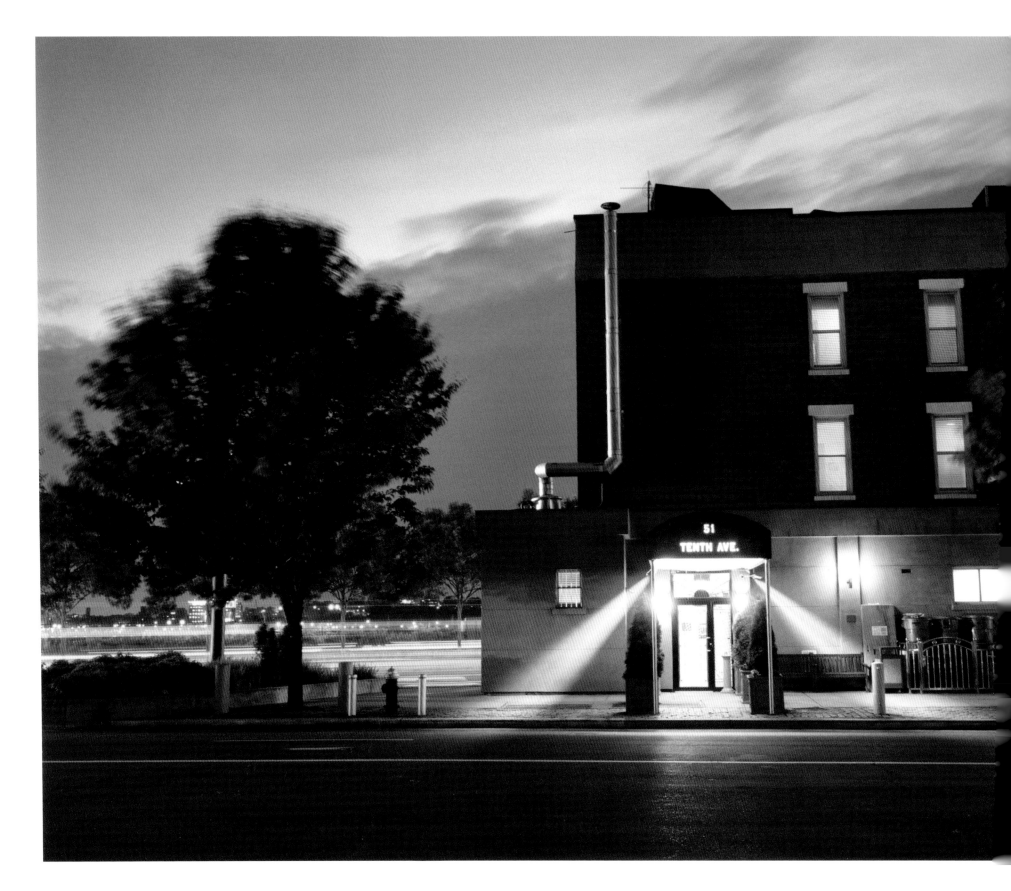

Liberty Inn

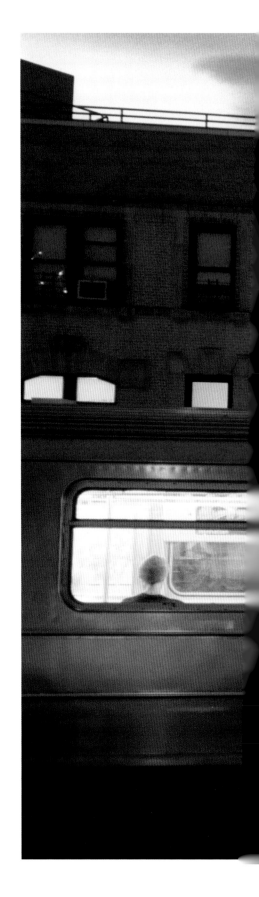

Subway, Manhattan

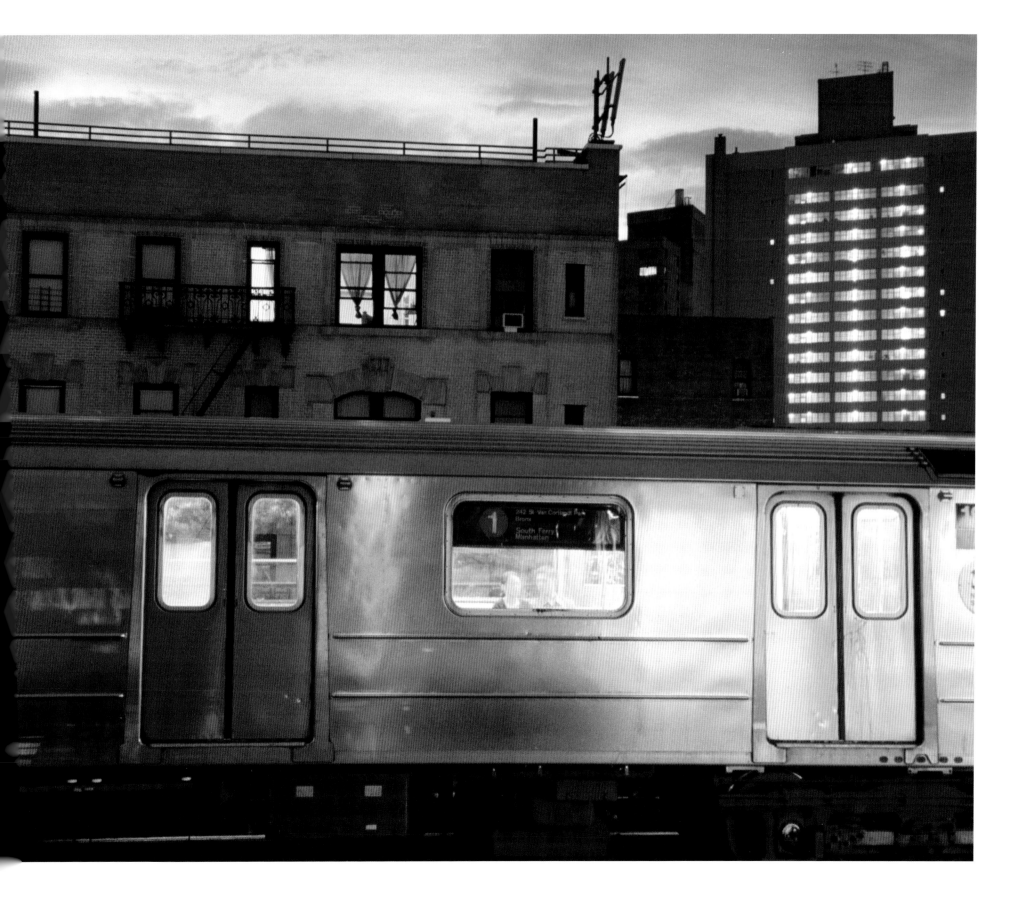

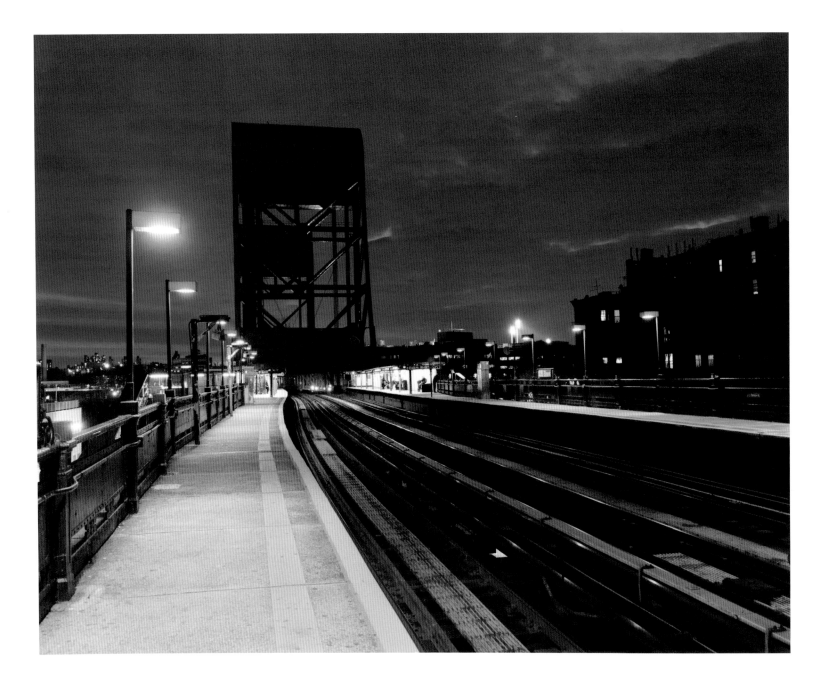

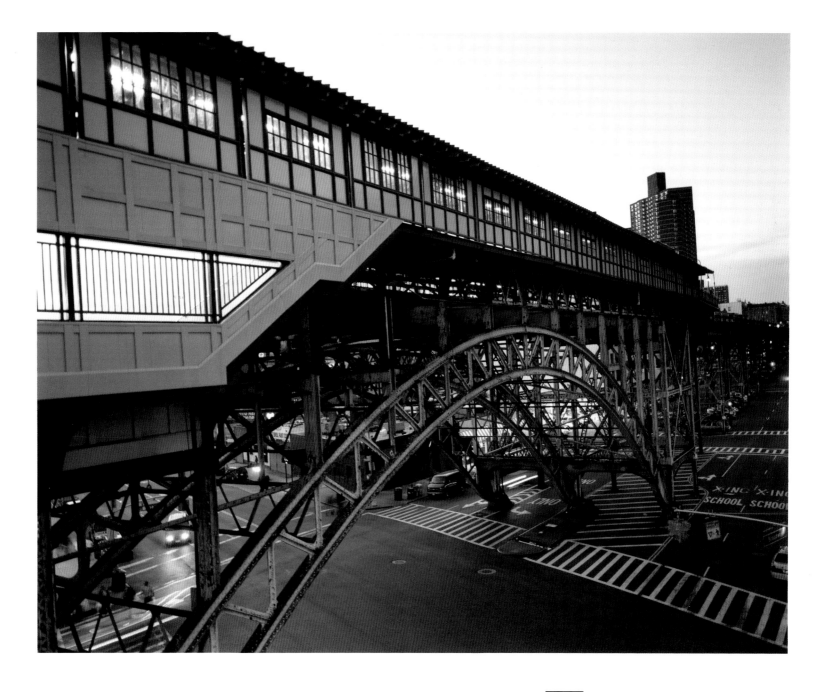

Elevated Subway Platform
Elevated Subway, West 125th Street

Truck Depot

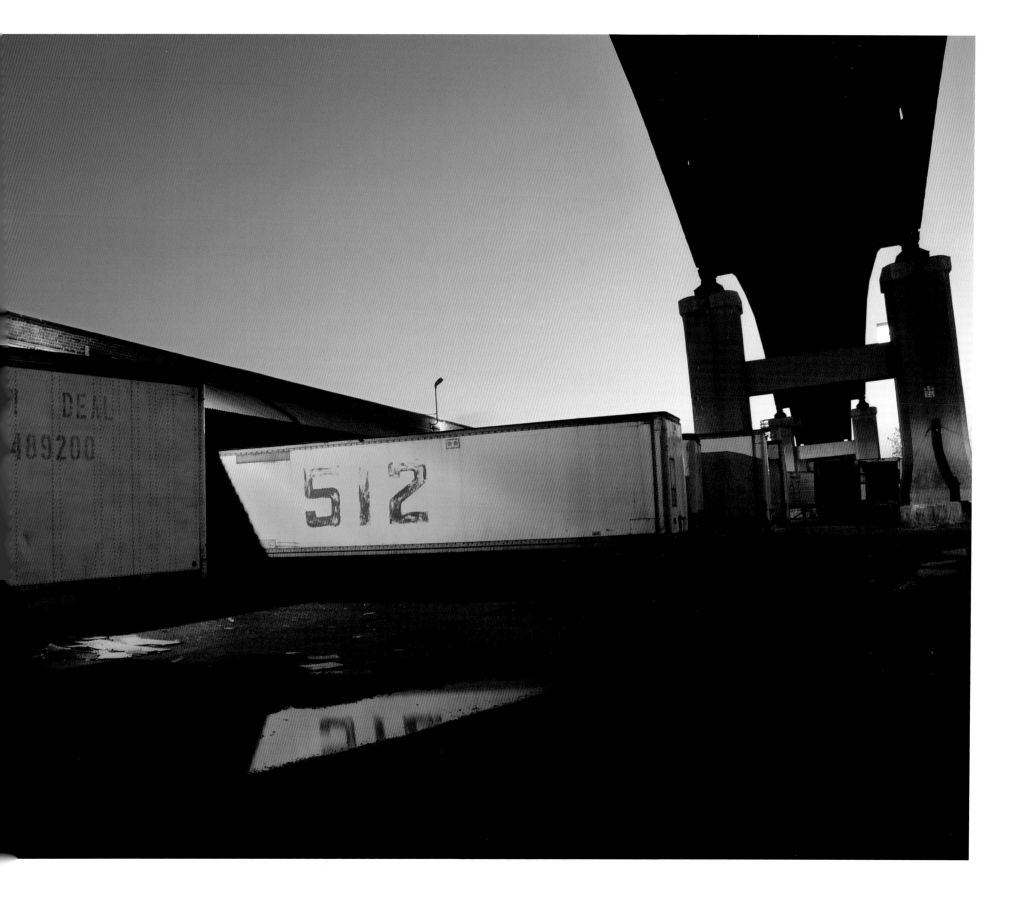

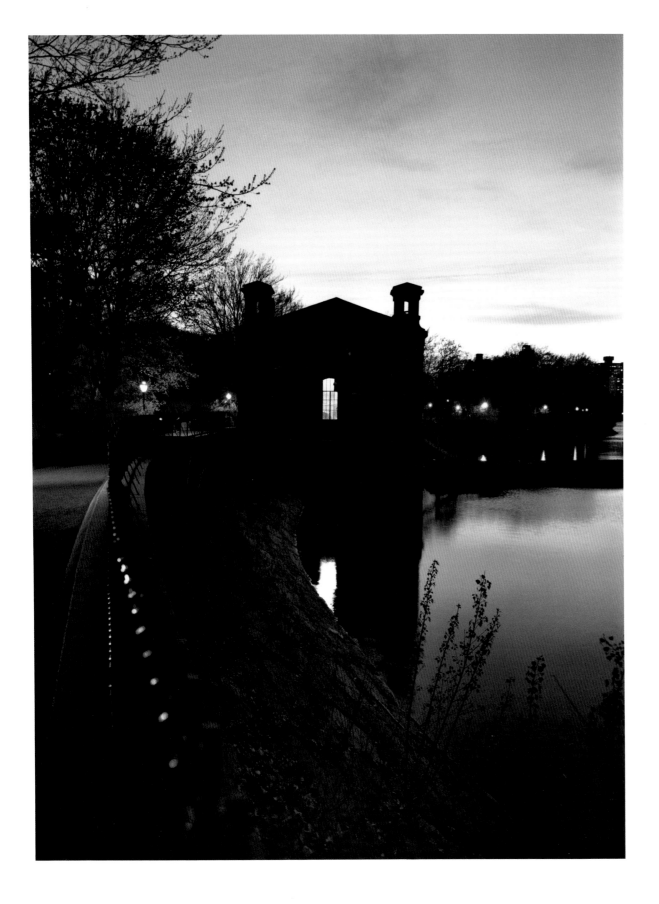

Reservoir, Central Park
Dipway Arch, Central Park

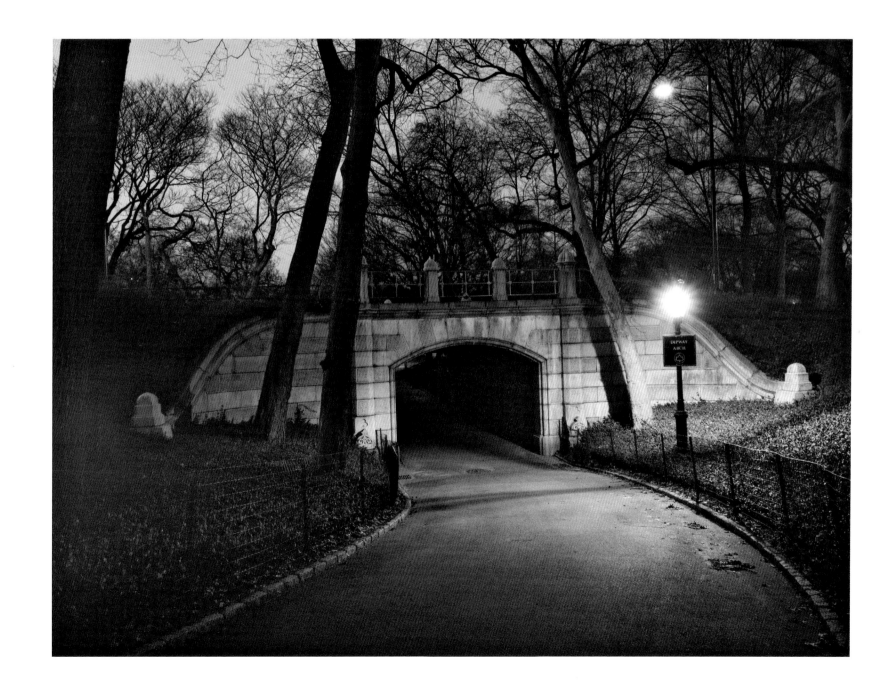

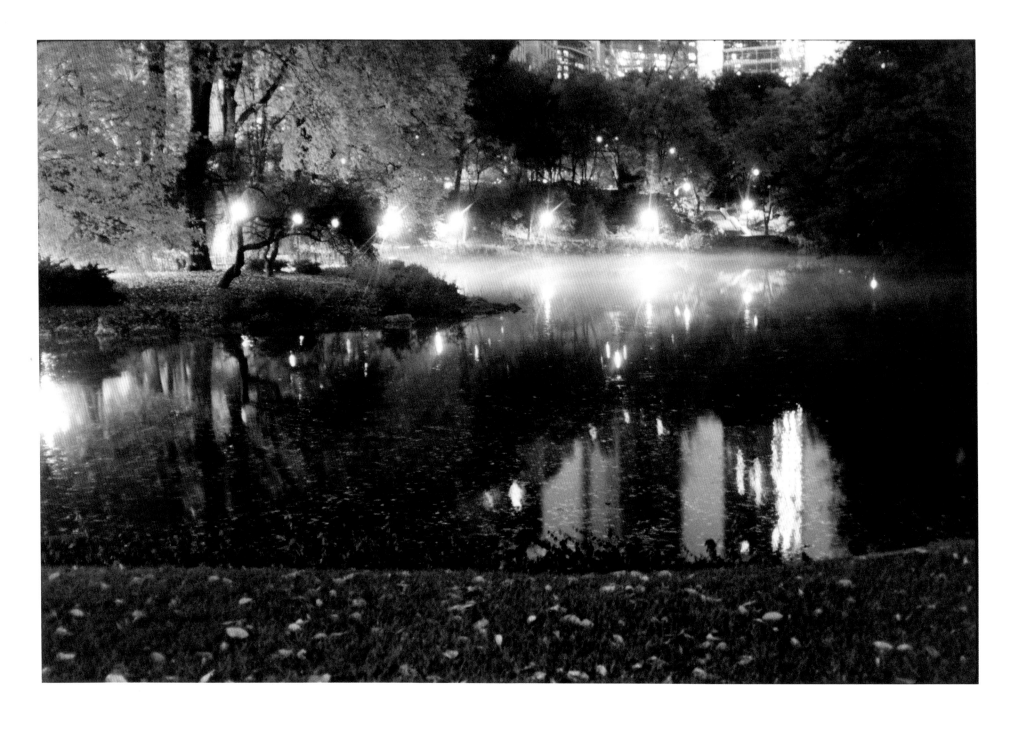

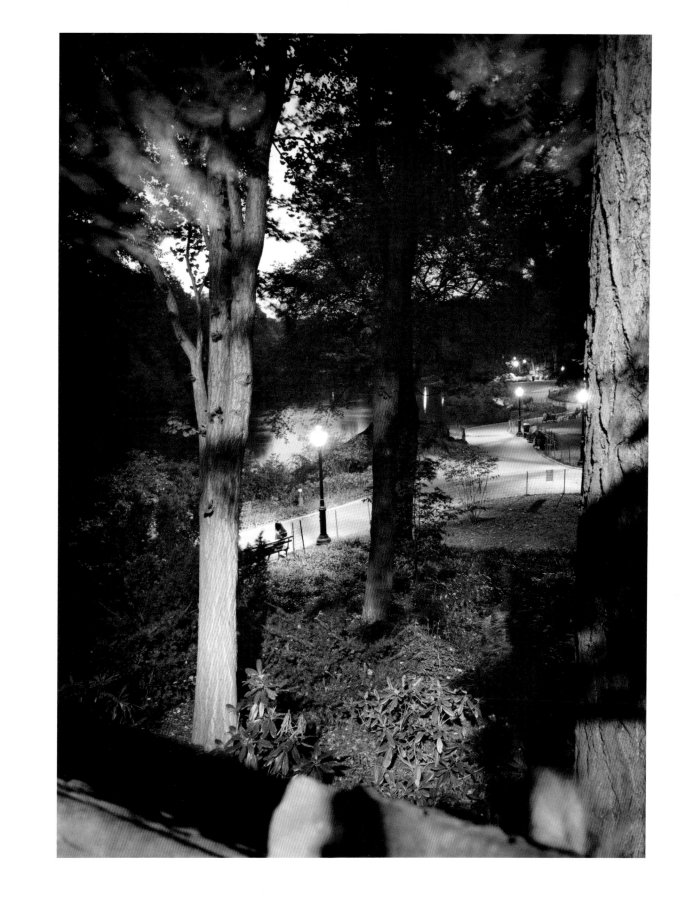

Central Park Pond
Central Park from 59th Street

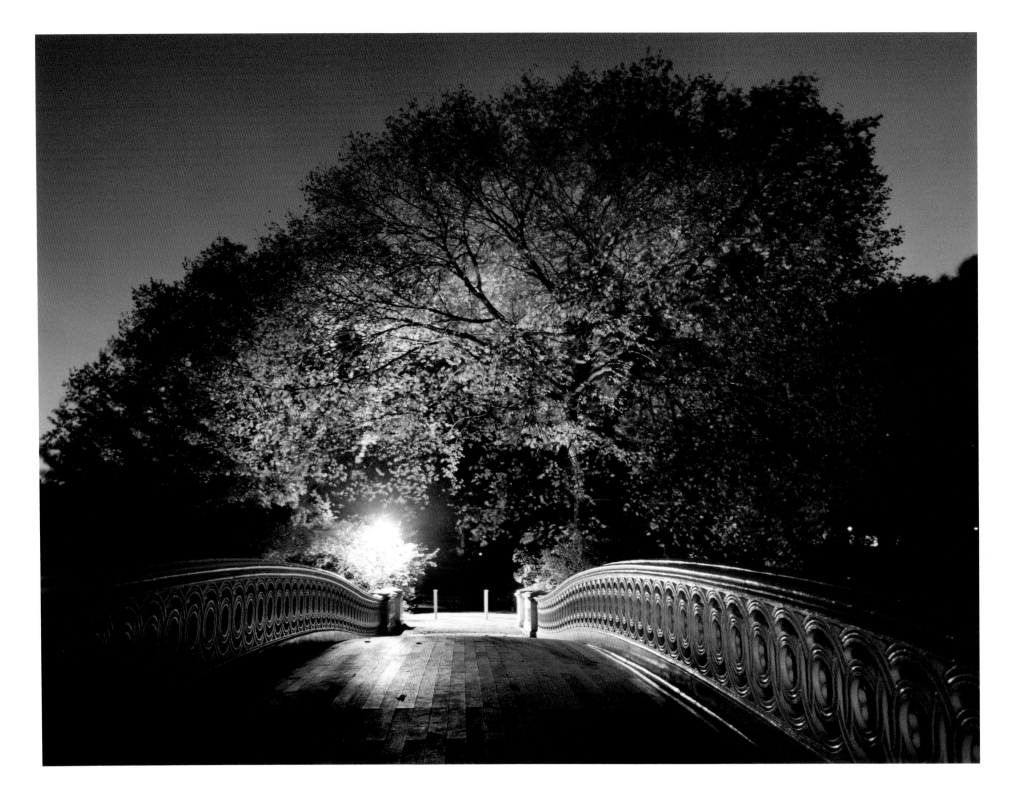

Bow Bridge, Central Park

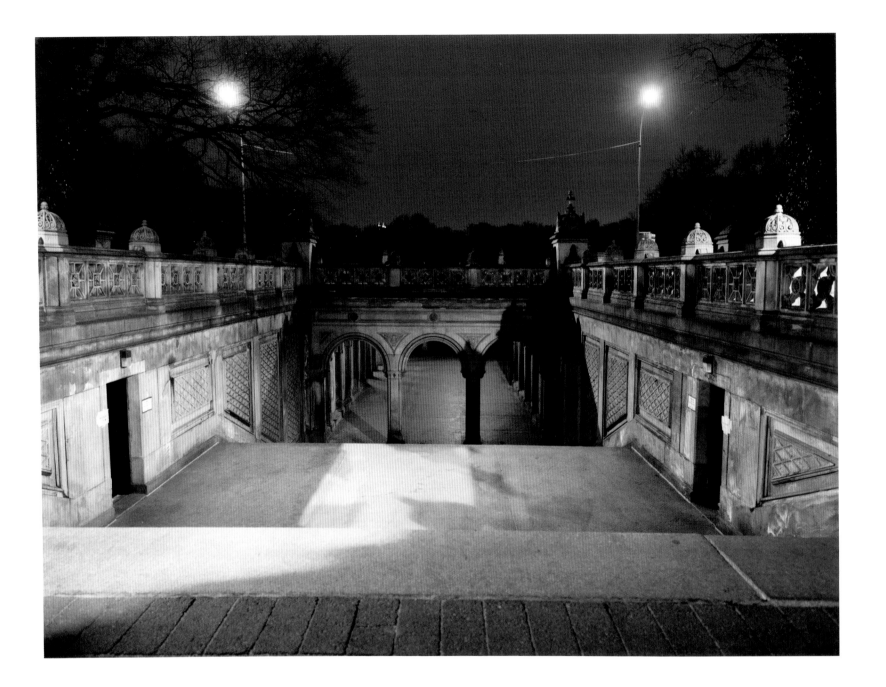

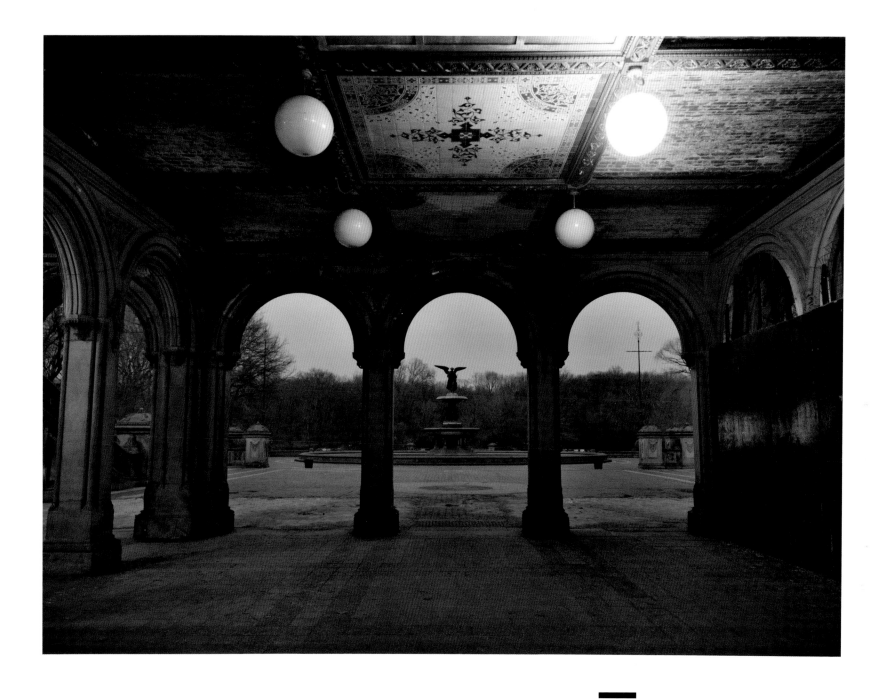

Bethesda Terrace, Central Park
Bethesda Fountain, Cental Park

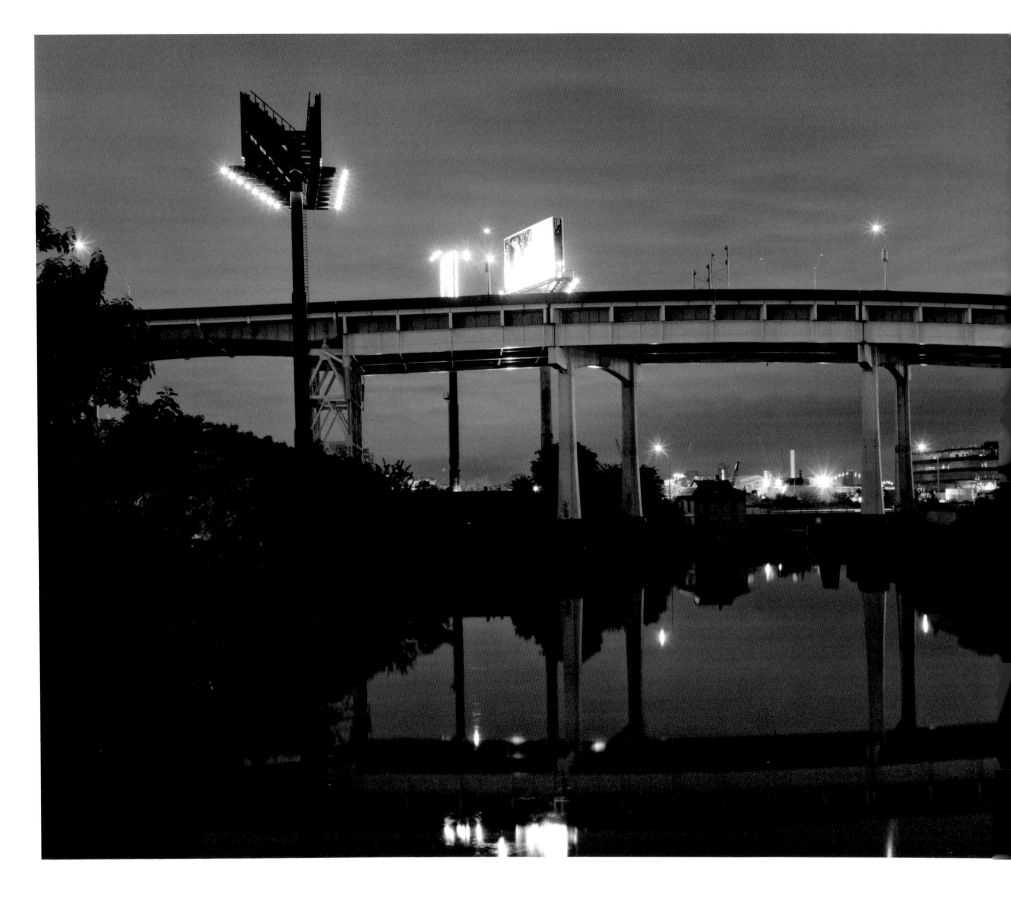

Long Island Expressway at Dutch Kills

Under the Manhattan Bridge

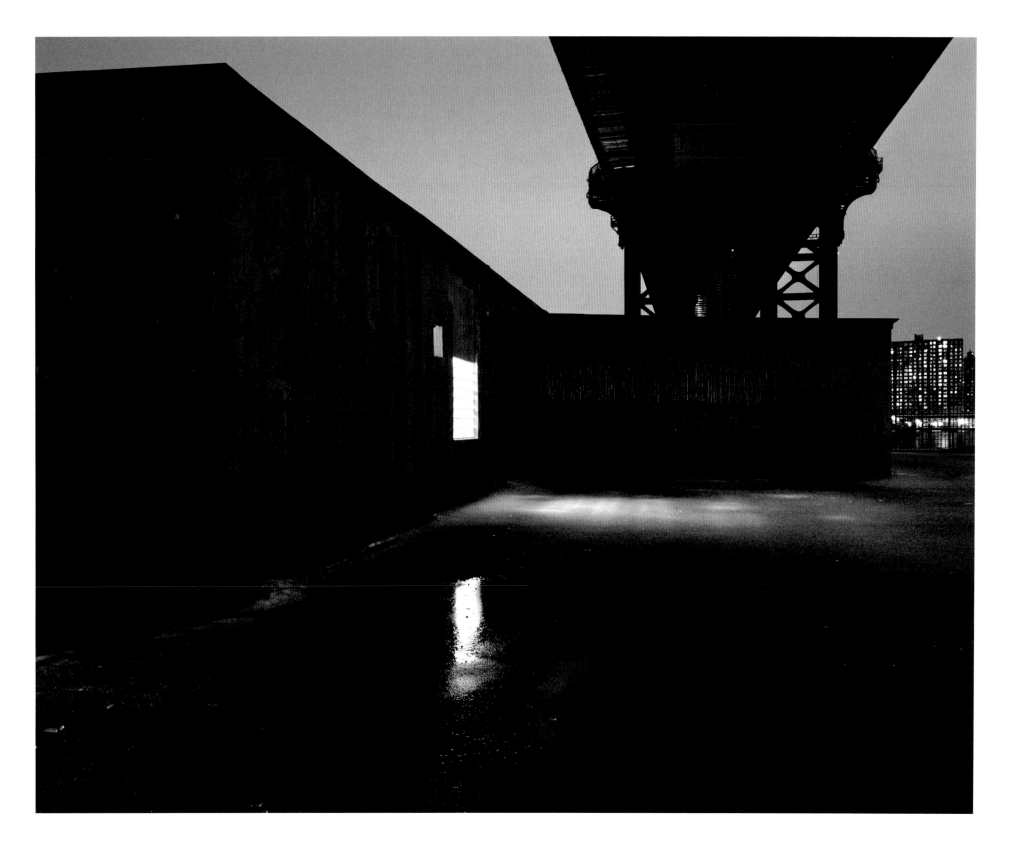

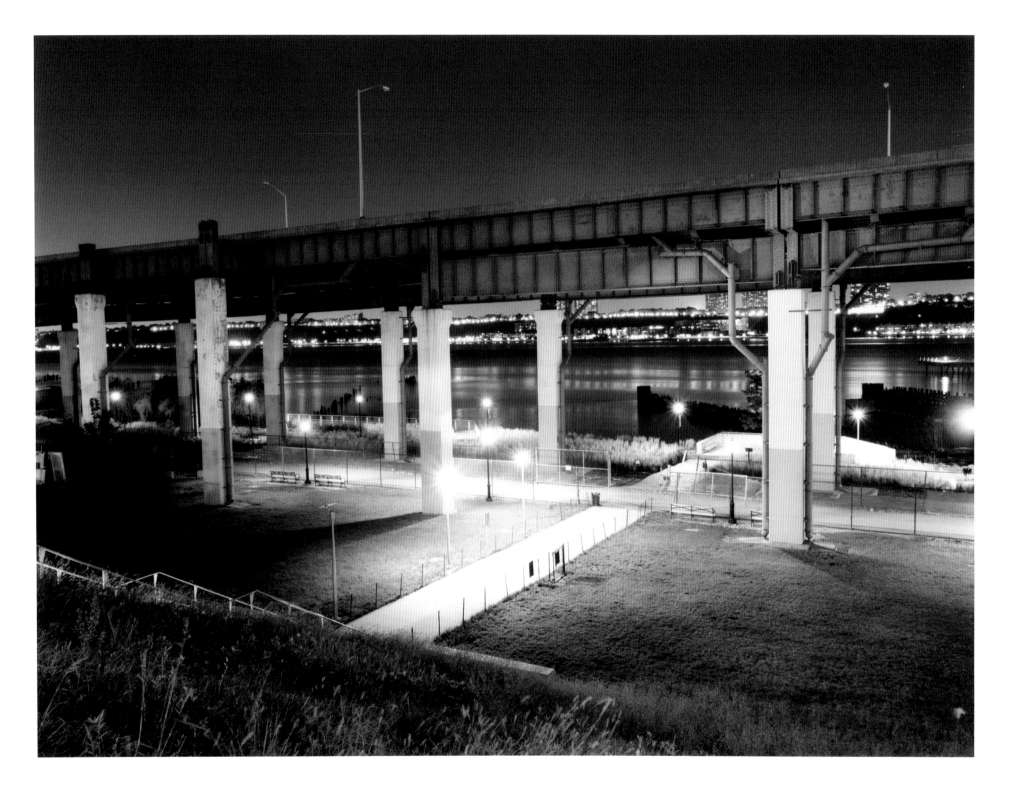

West 65th Street and Hudson River

Simone's Boat

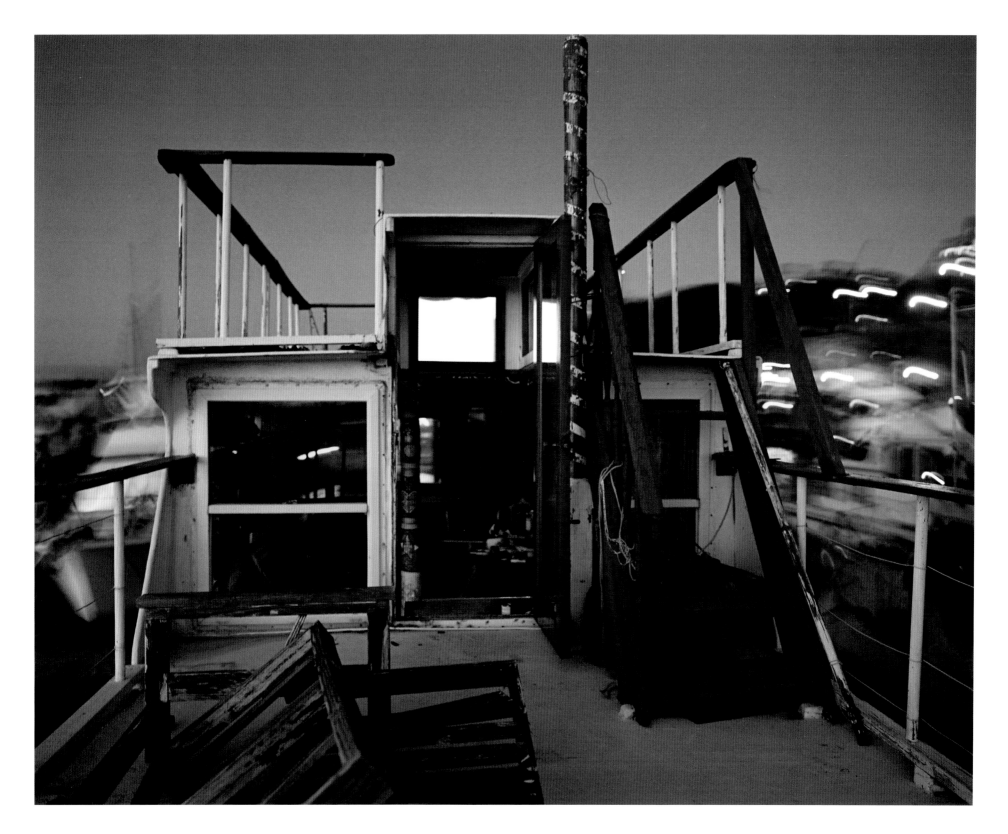

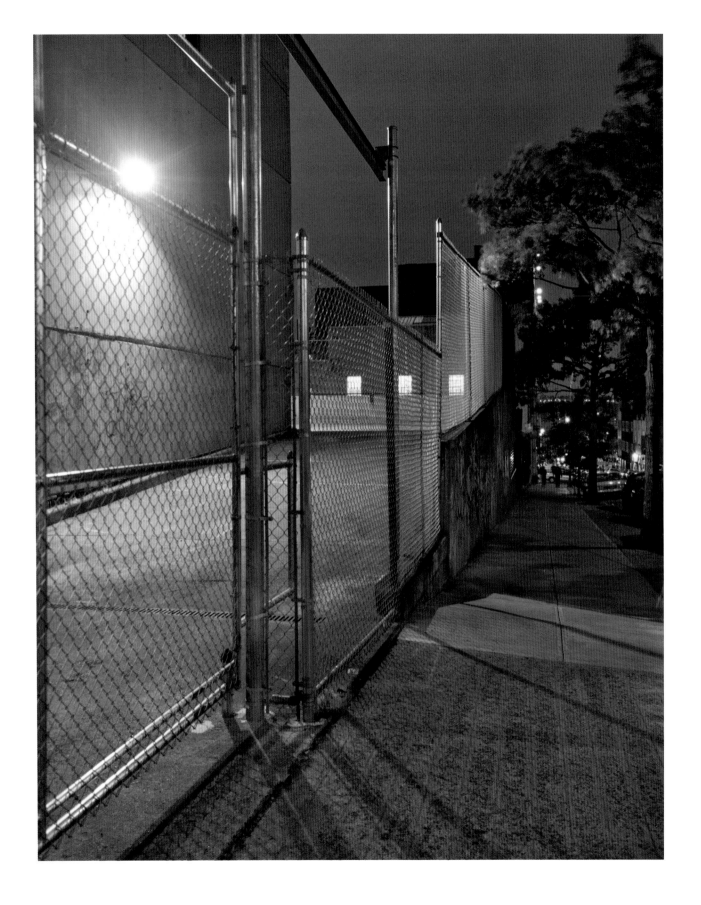

West 55th Street
Black House, Red Hook, Brooklyn

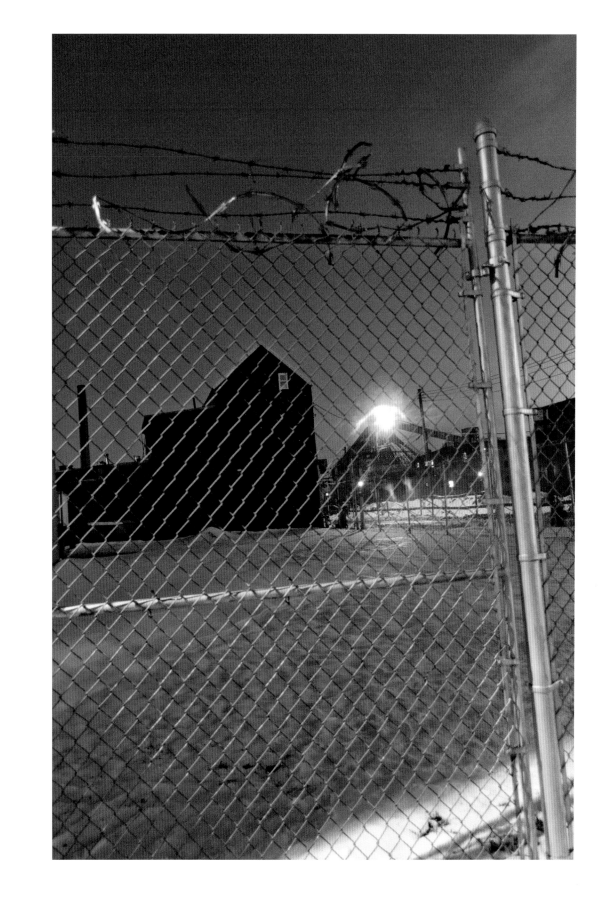

Reed Street

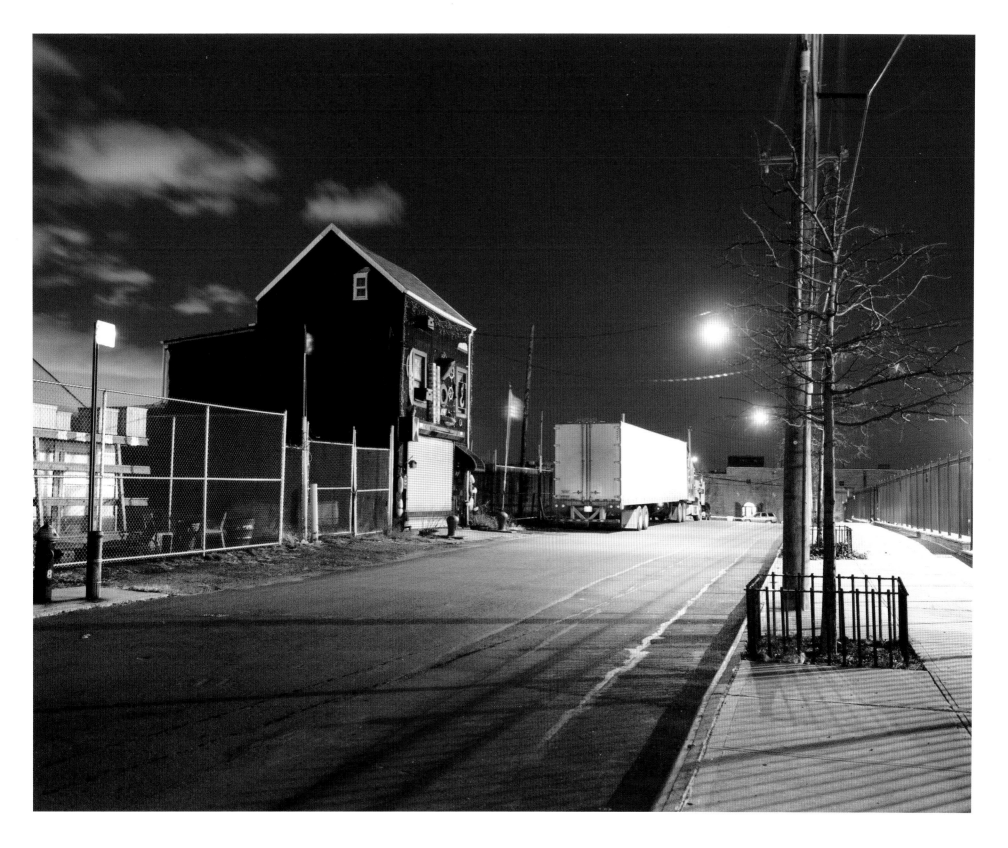

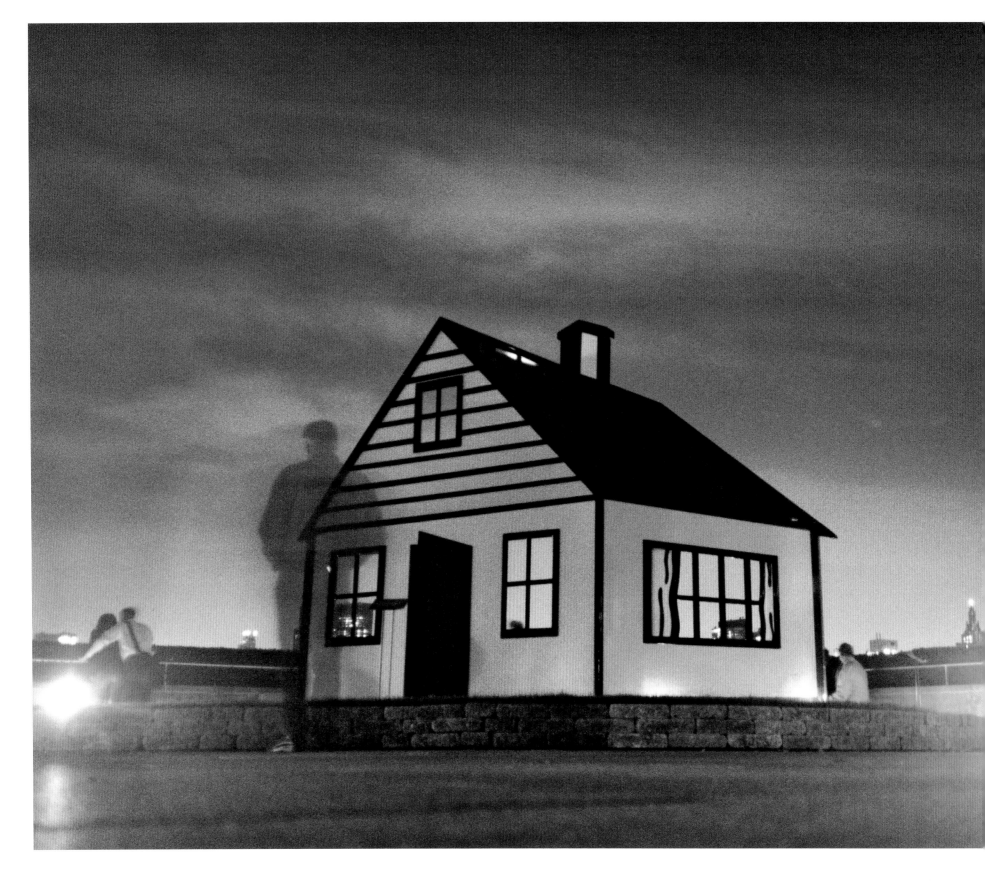

Metropolitan Museum Roof

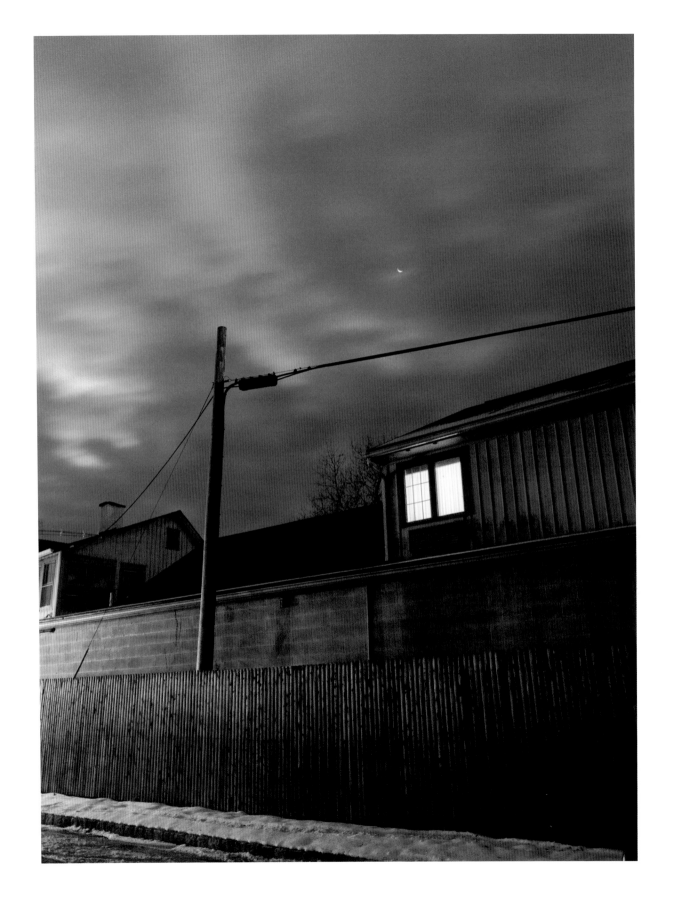

Mill Street
Storm

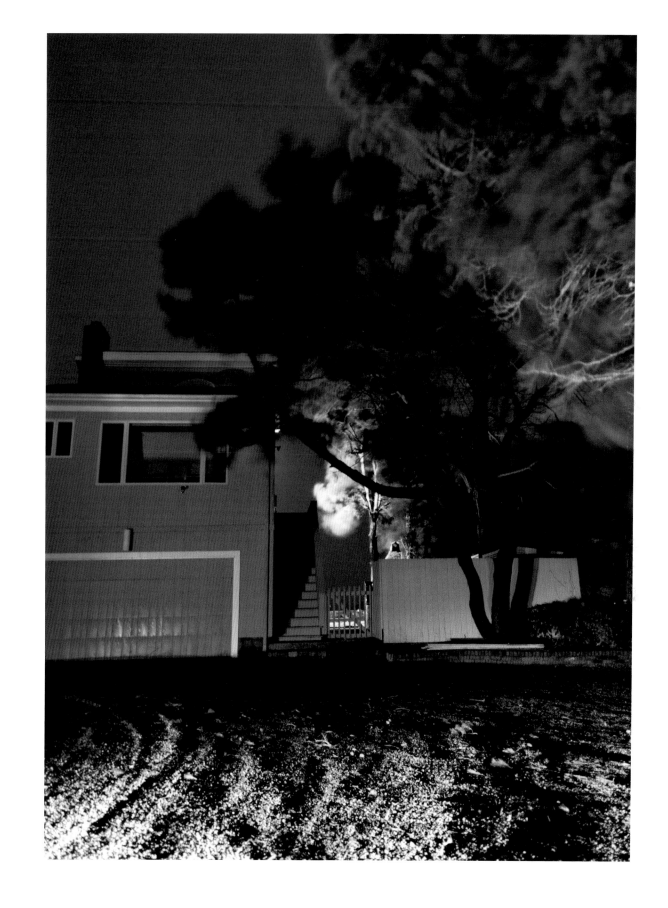

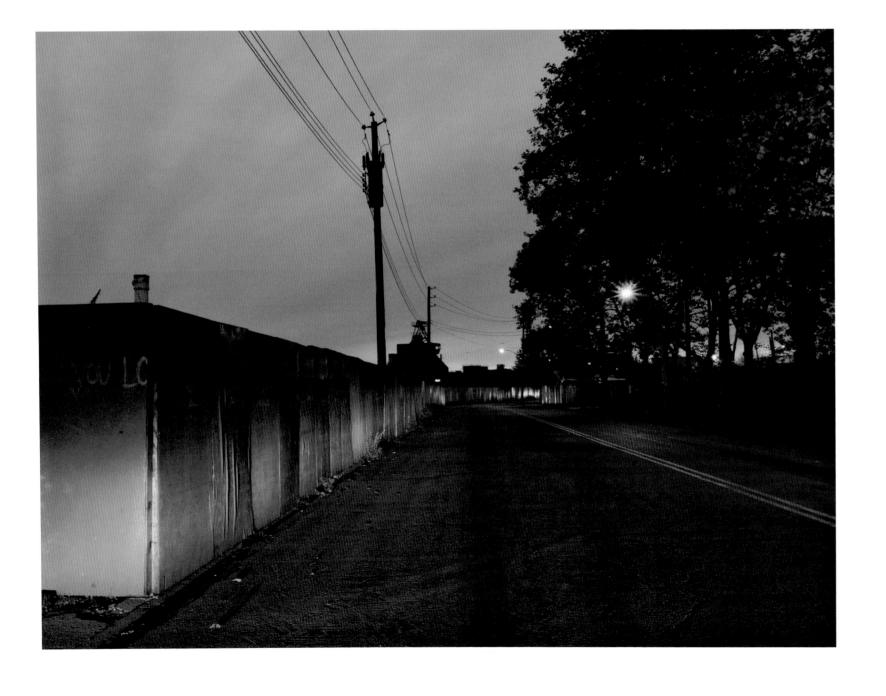

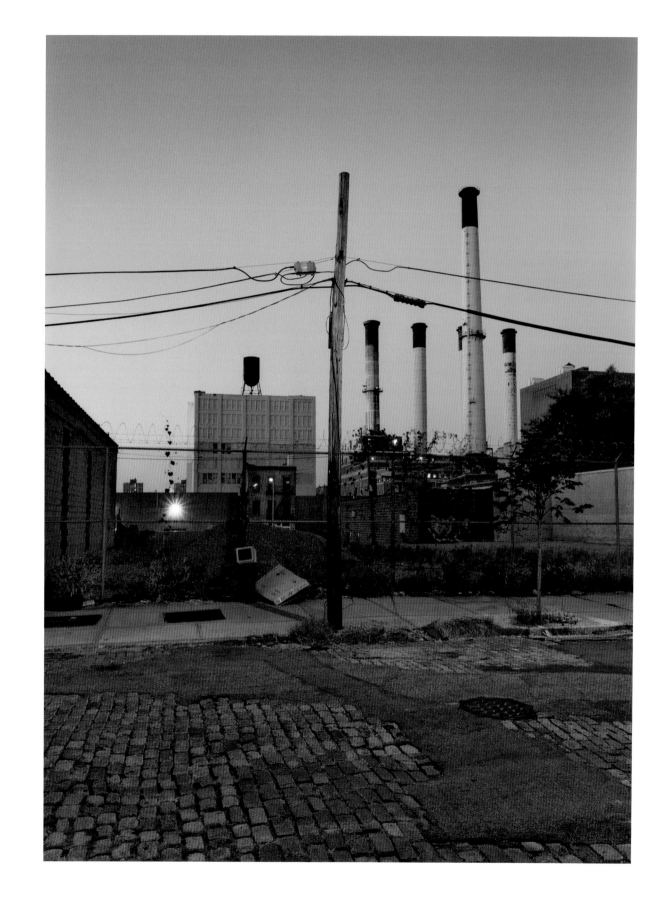

Halleck Street
Front Street

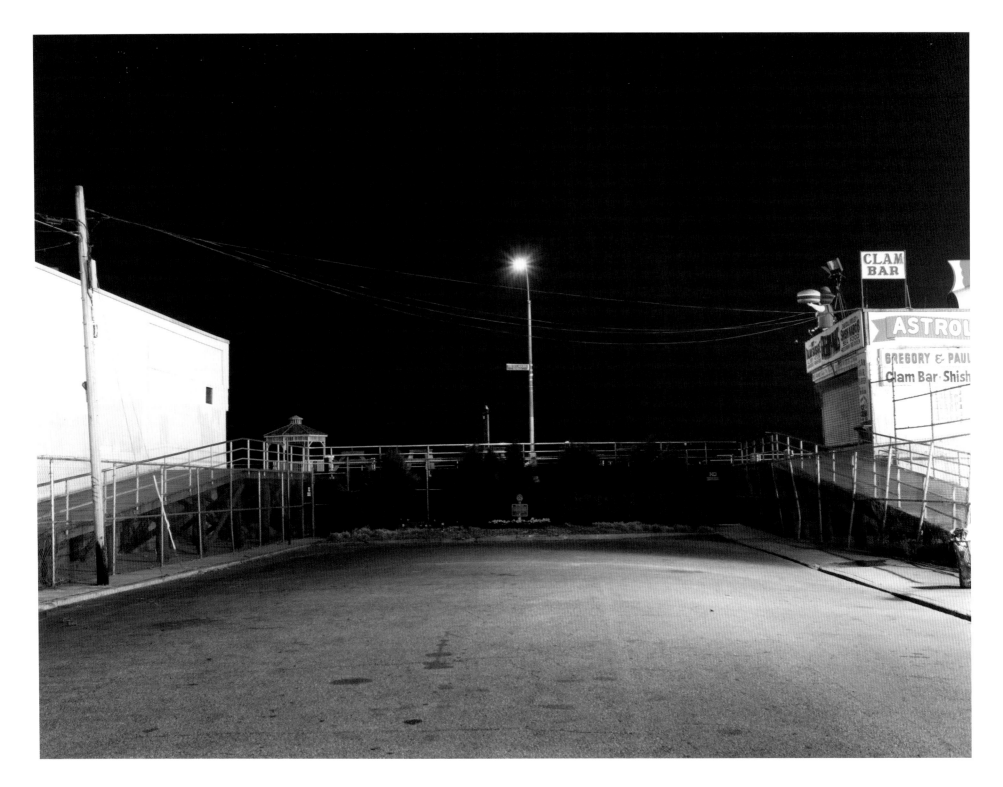

Jones Walk, Coney Island

Driggs Avenue

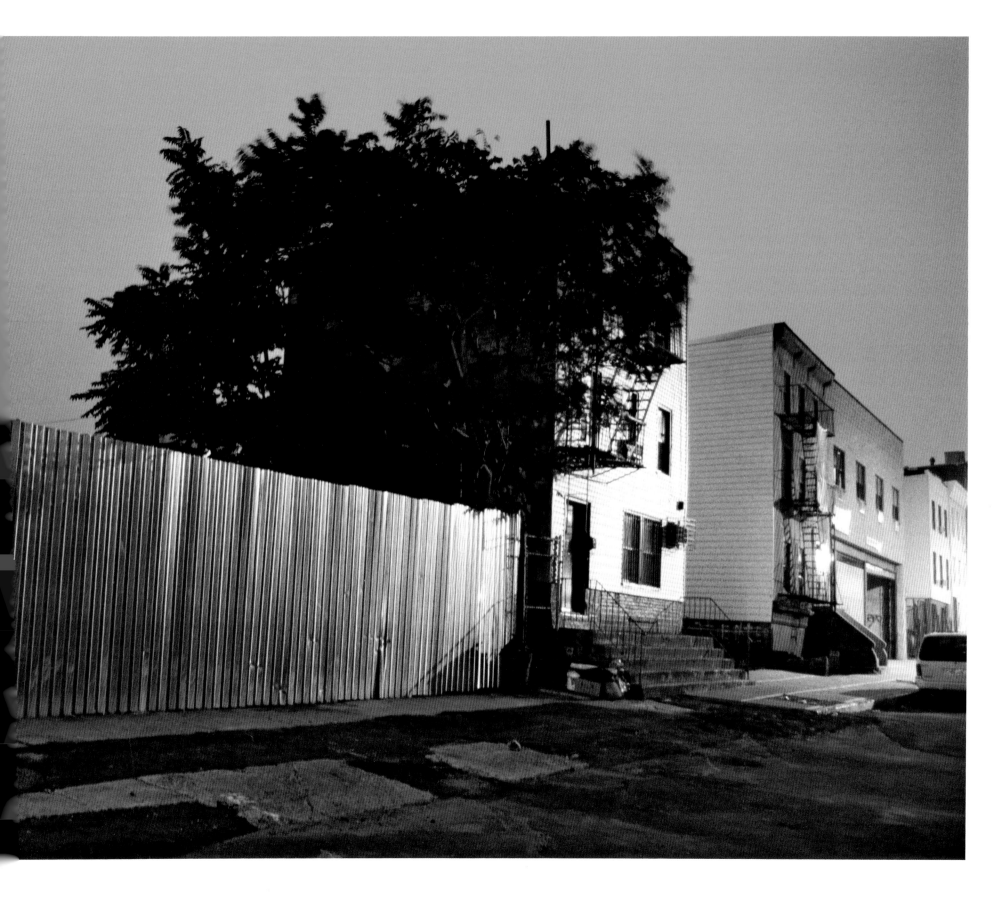

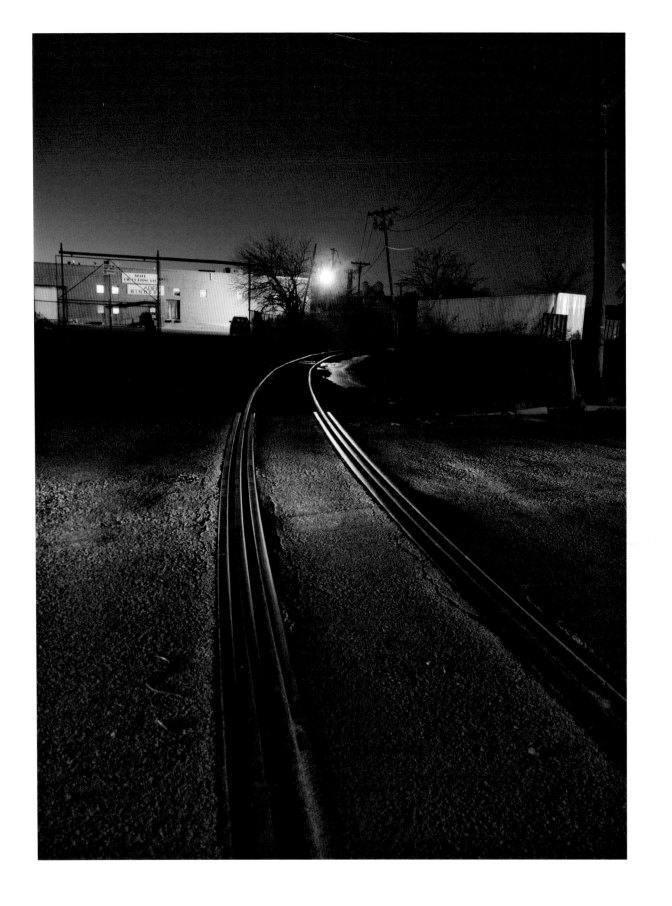

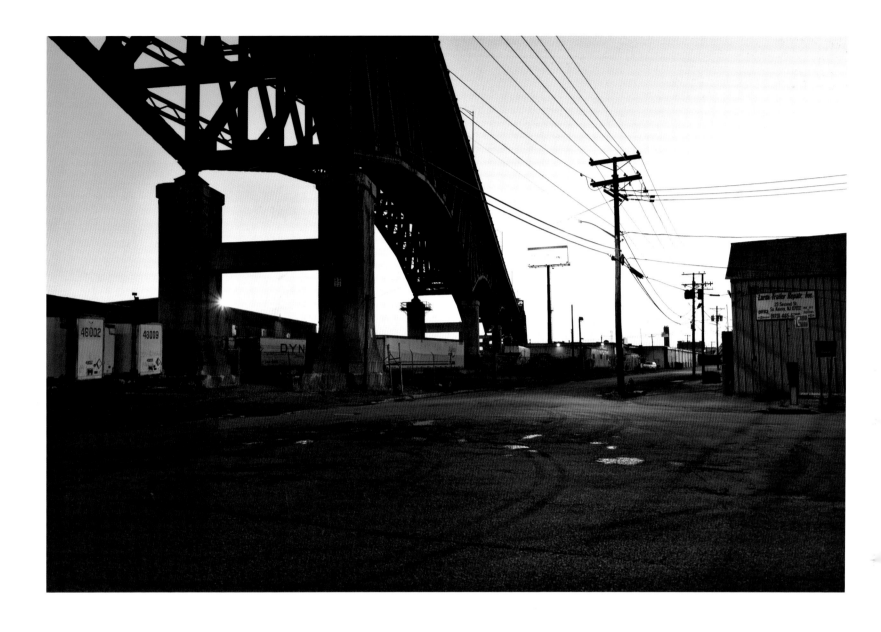

Industrial Railyards
Second Street

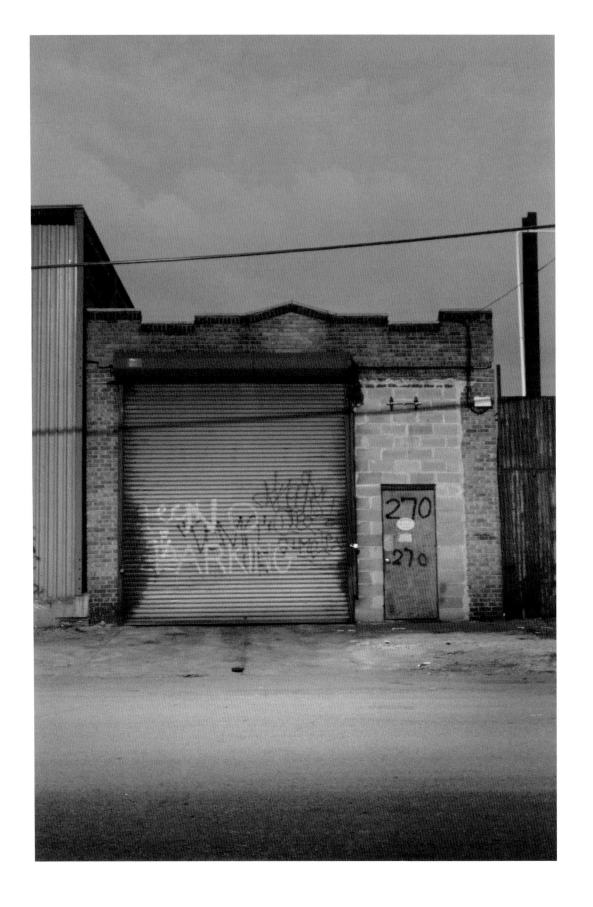

India Street

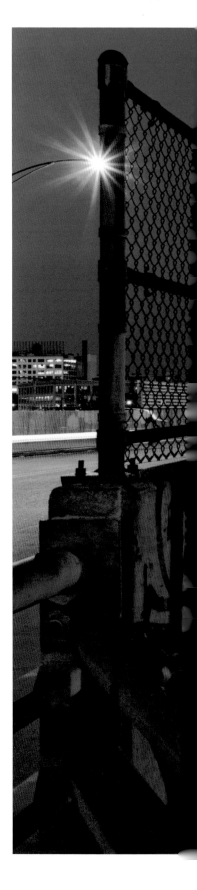

Stillwell Avenue

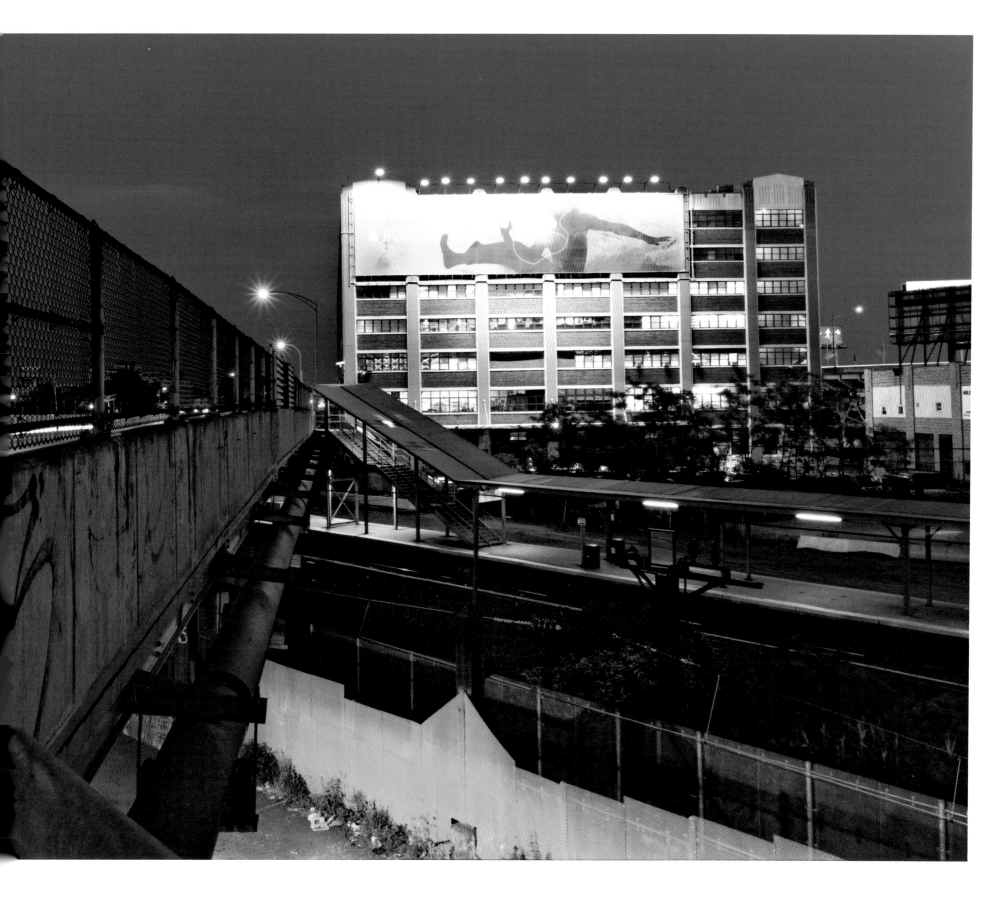

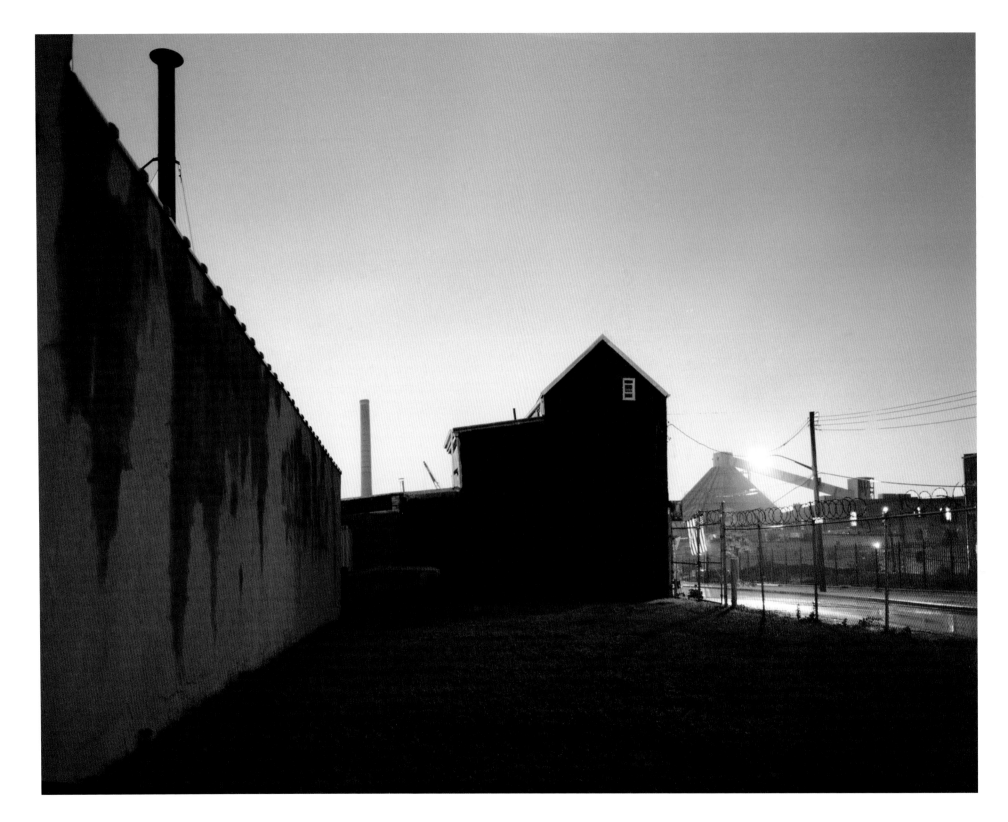

Black House

Wythe Avenue

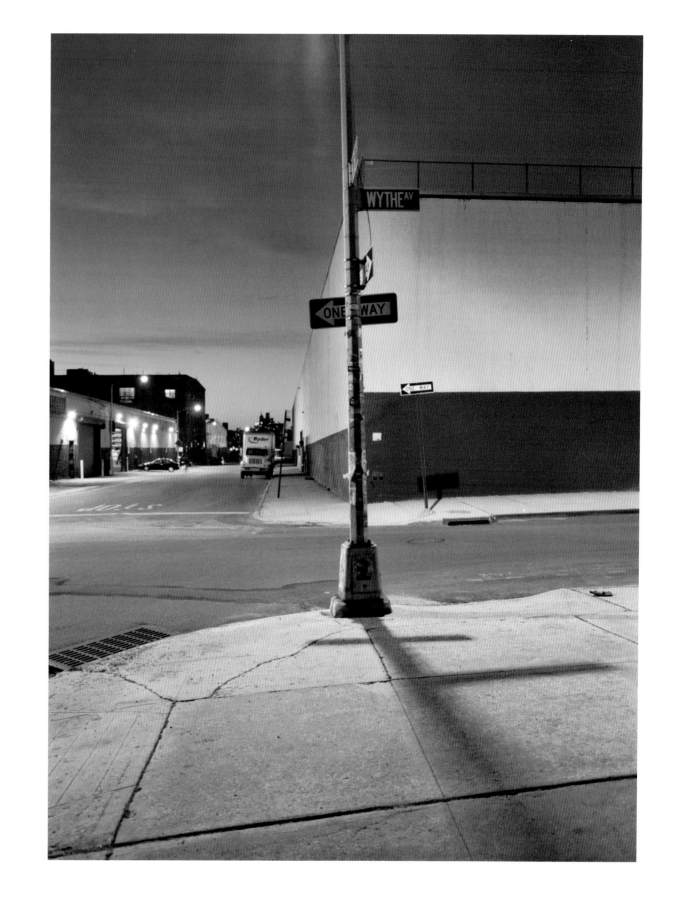

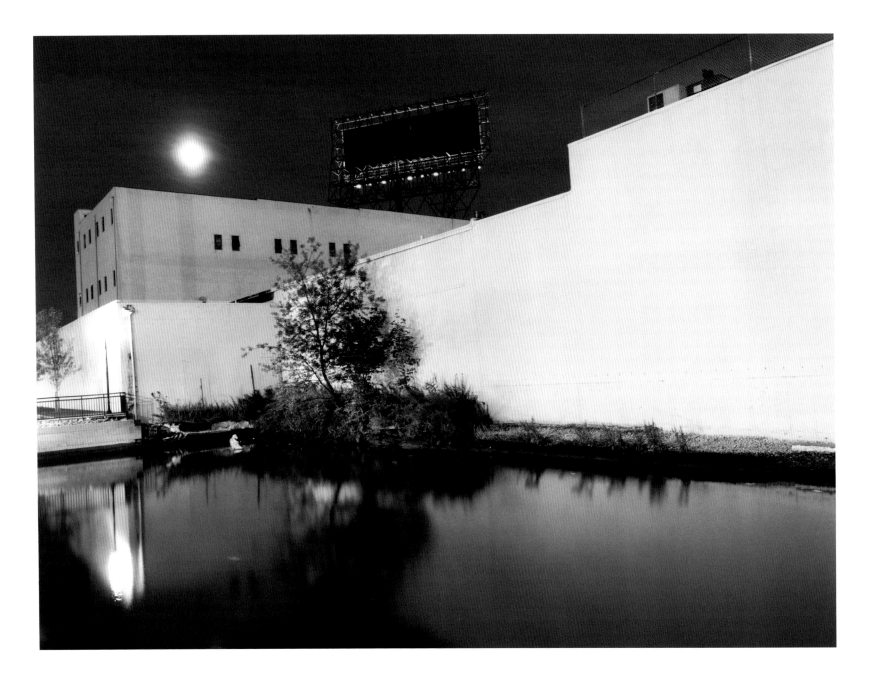

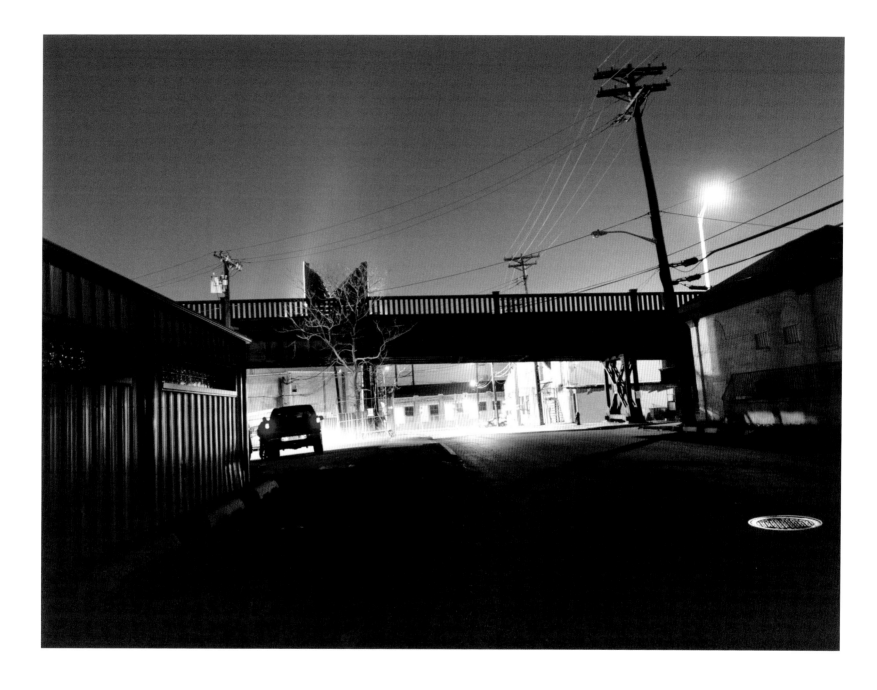

Gowanus Canal
Belleville Turnpike

—— Number 1 Line

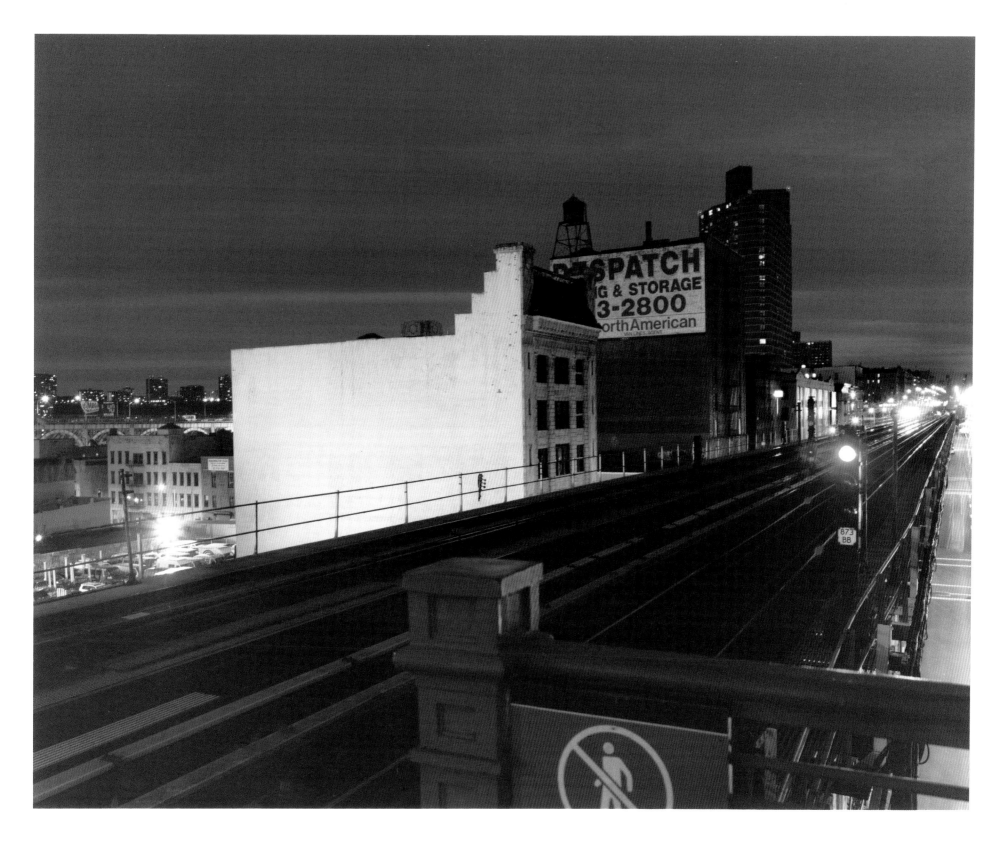

Gowanus Canal

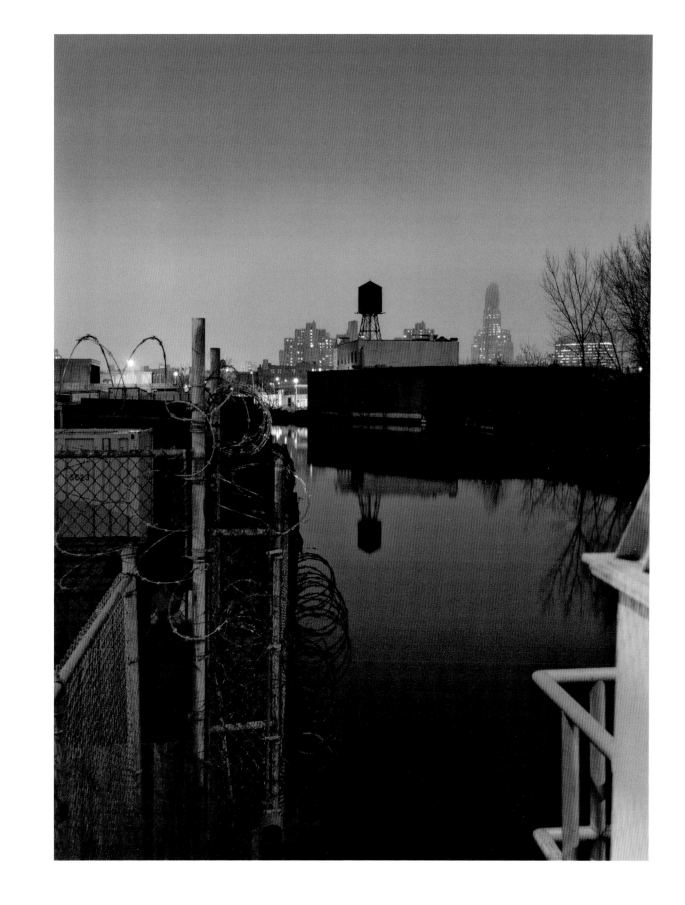

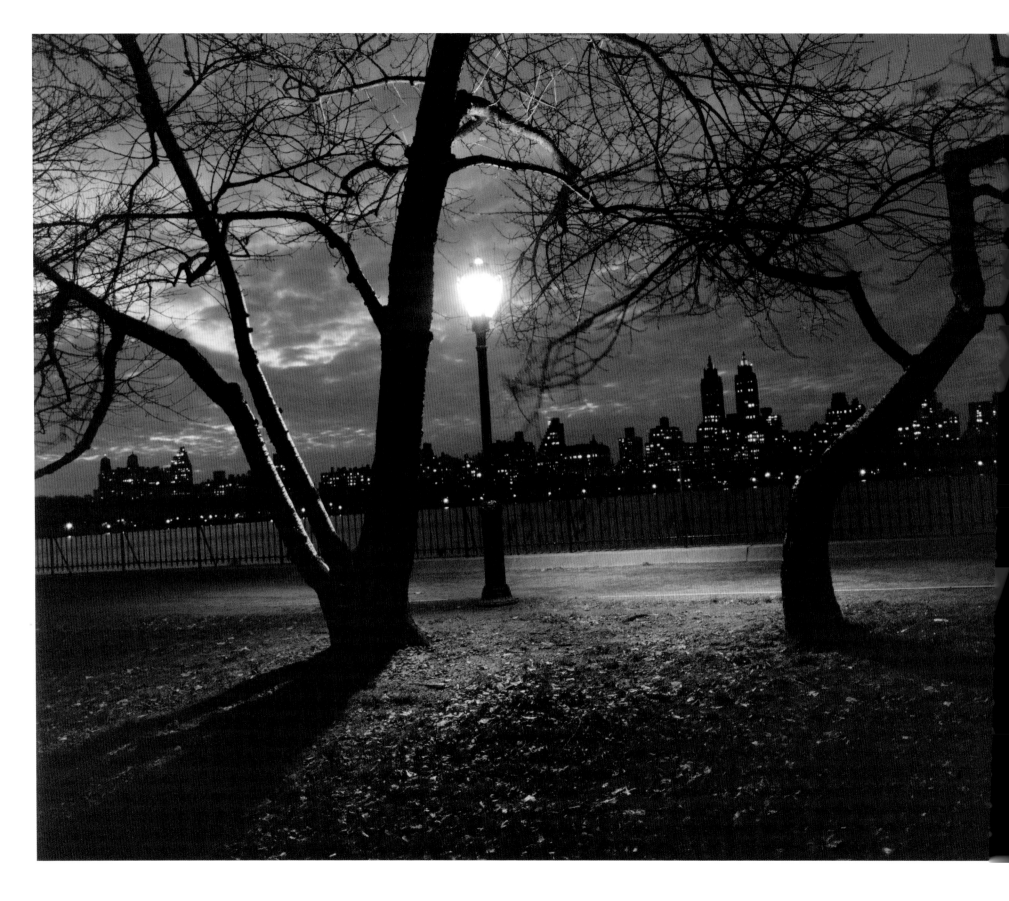

Central Park

Riverside Drive

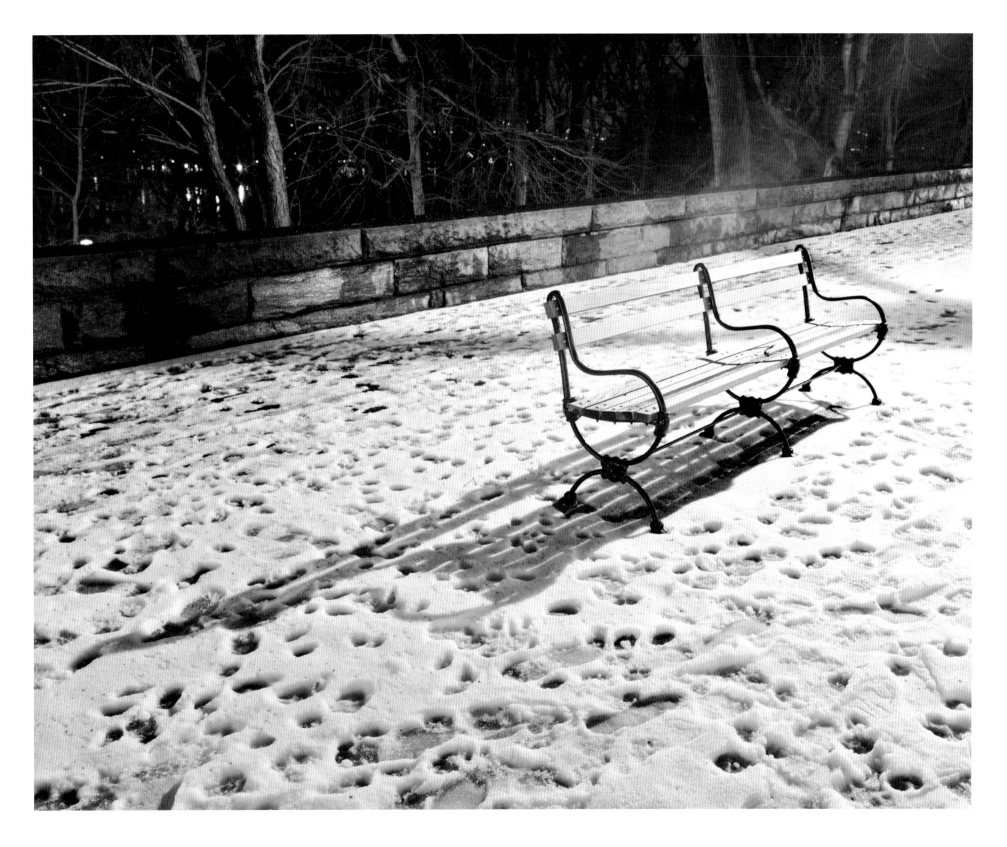

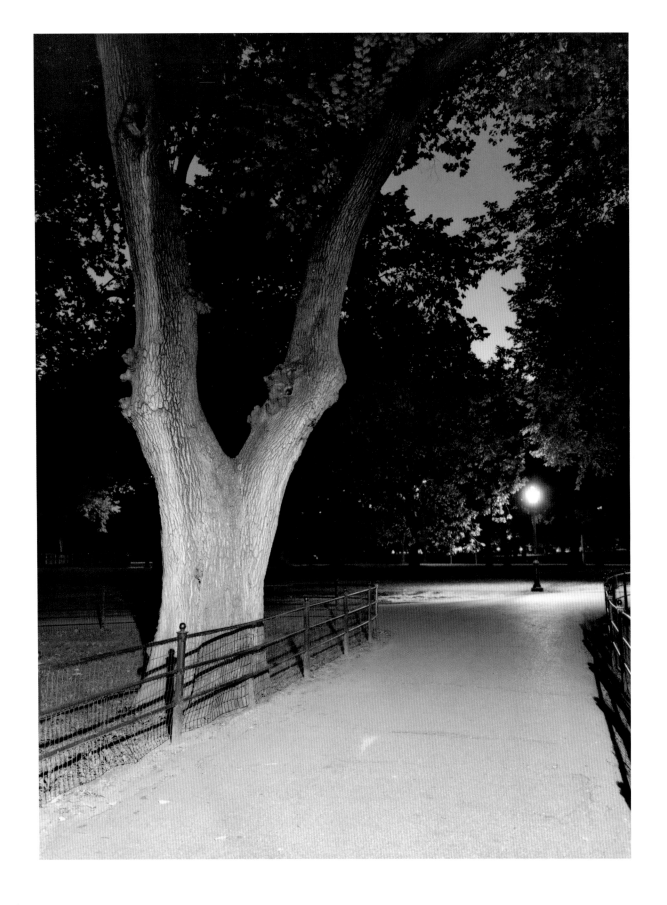

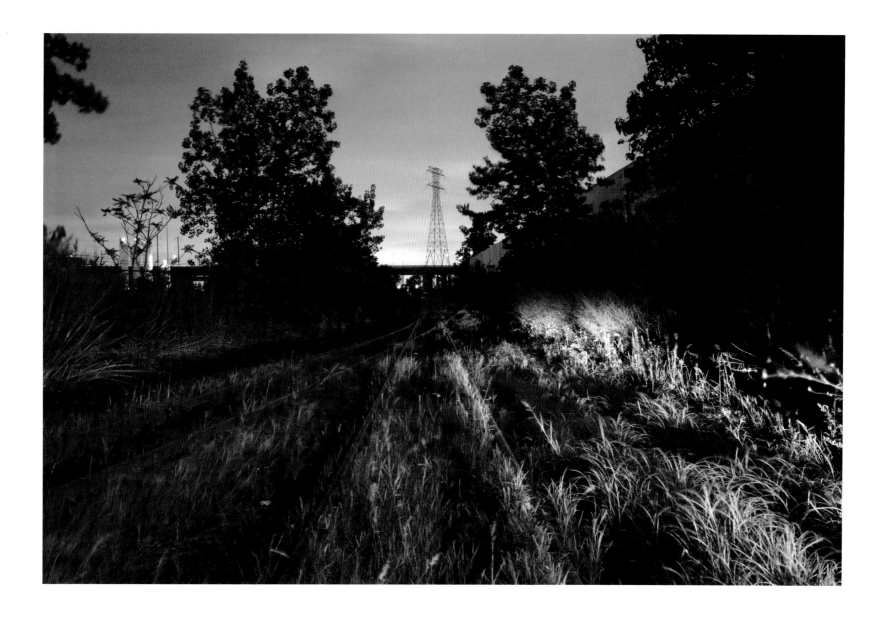

Central Park
Borchard Street

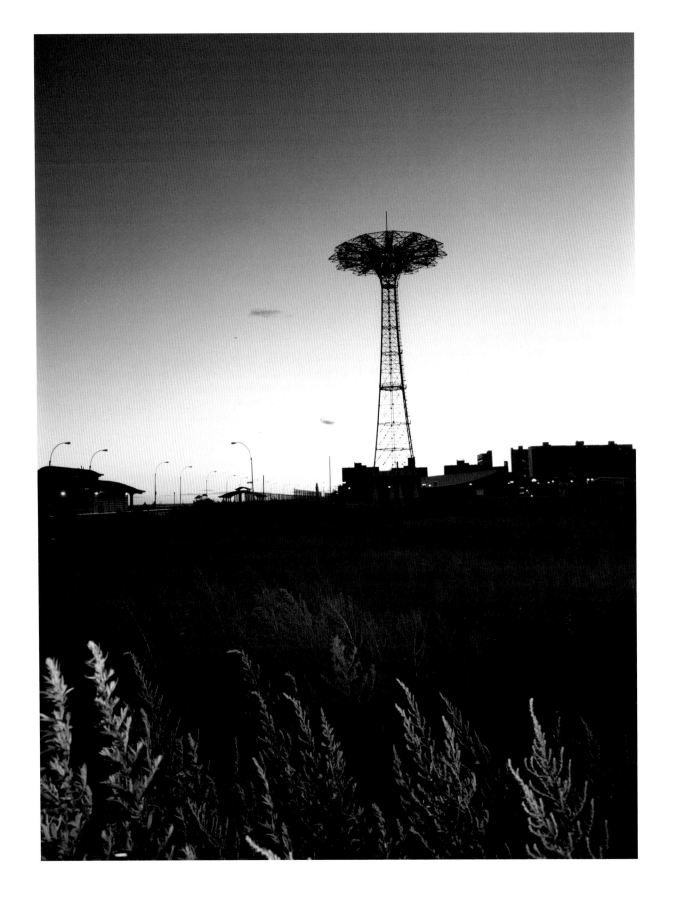

Parachute Jump
Hudson River at Riverside Park

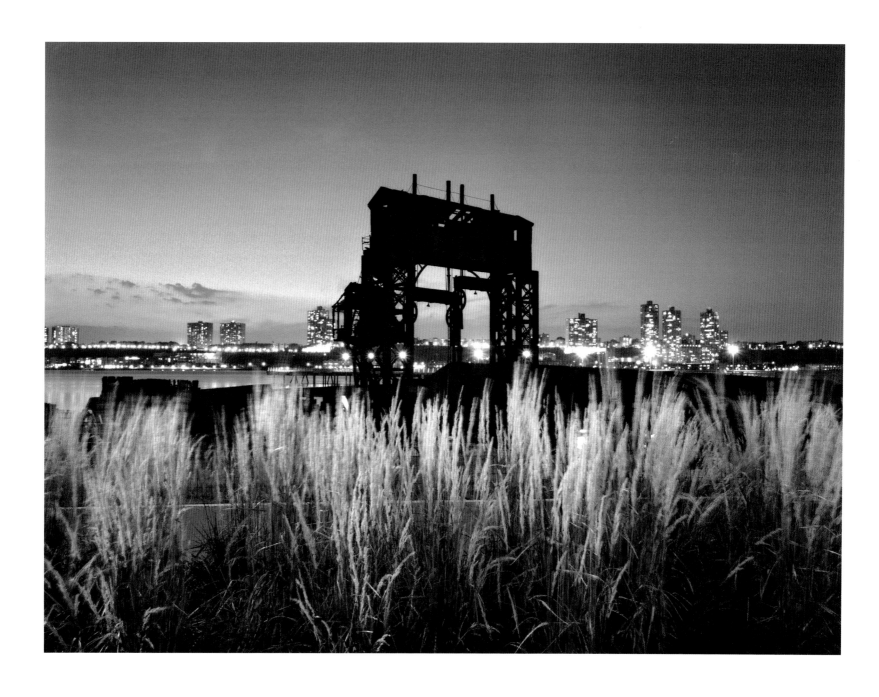

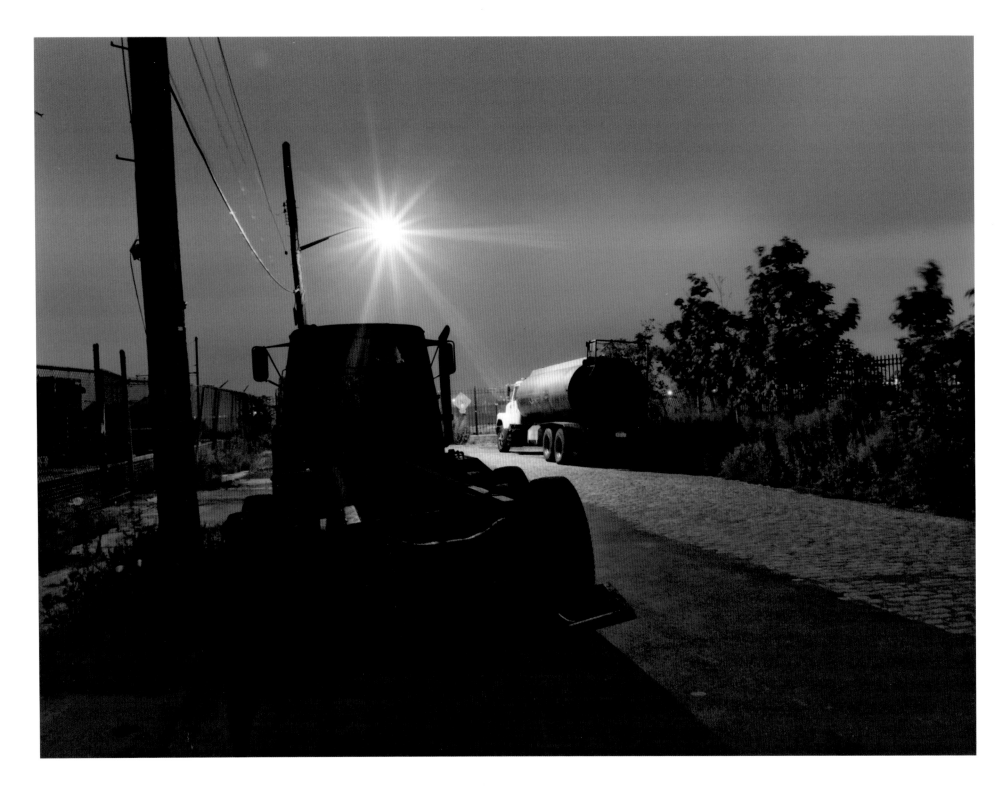

Trucks on Conover Street

Fish House Road

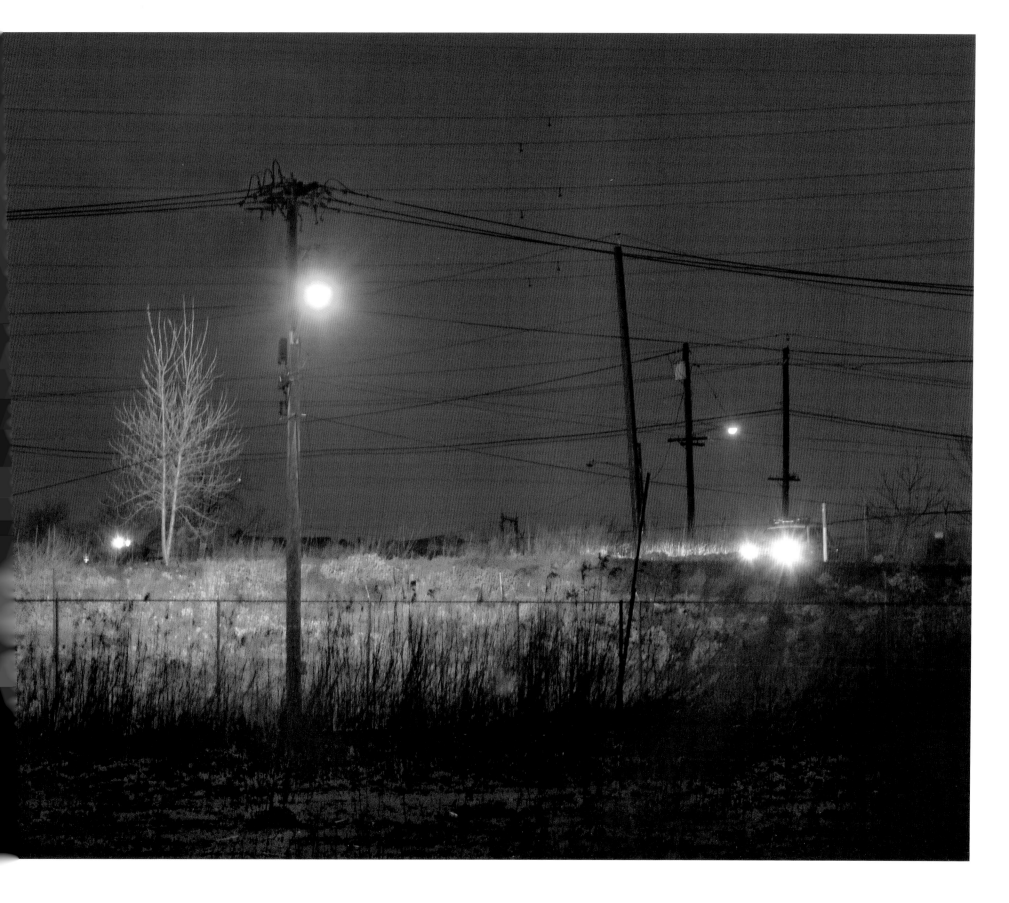

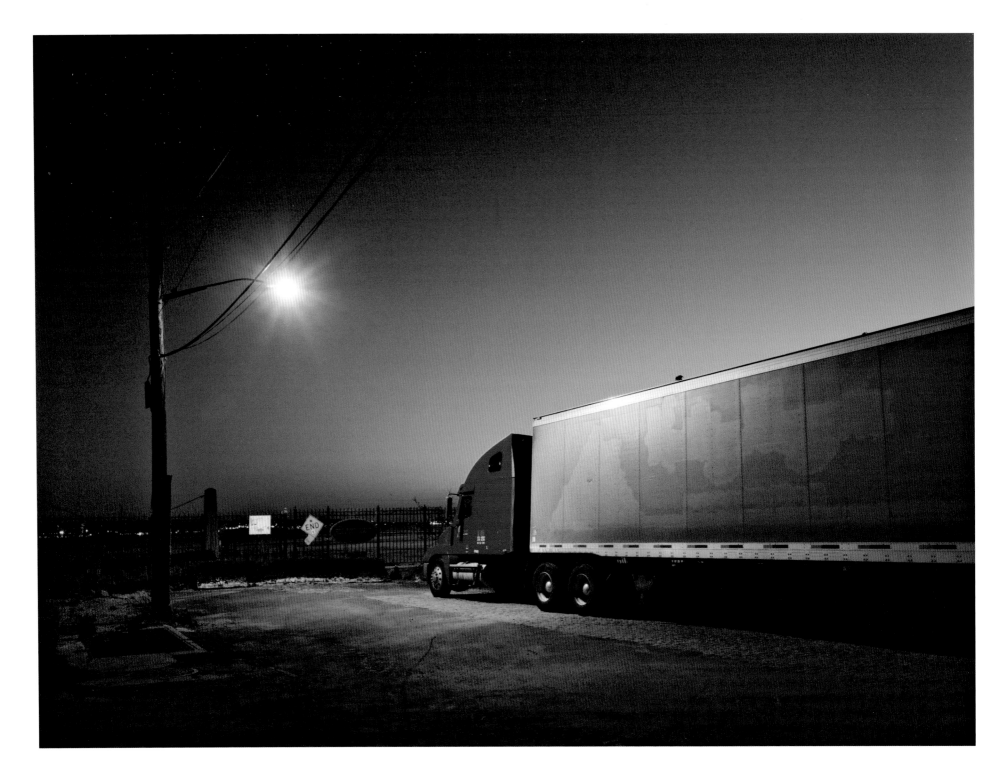

Conover Street

Brooklyn Bridge

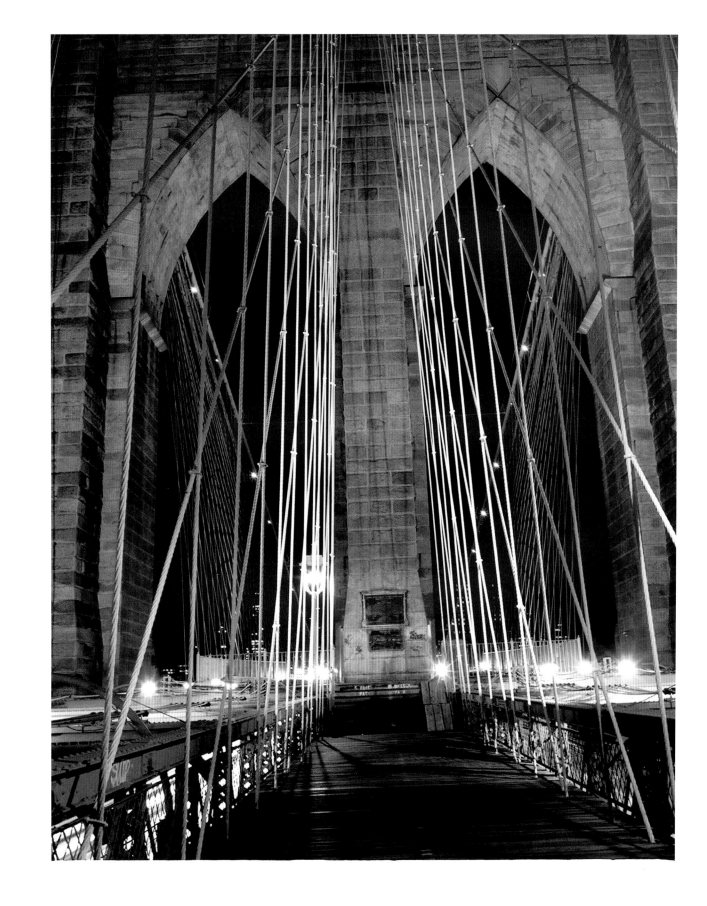

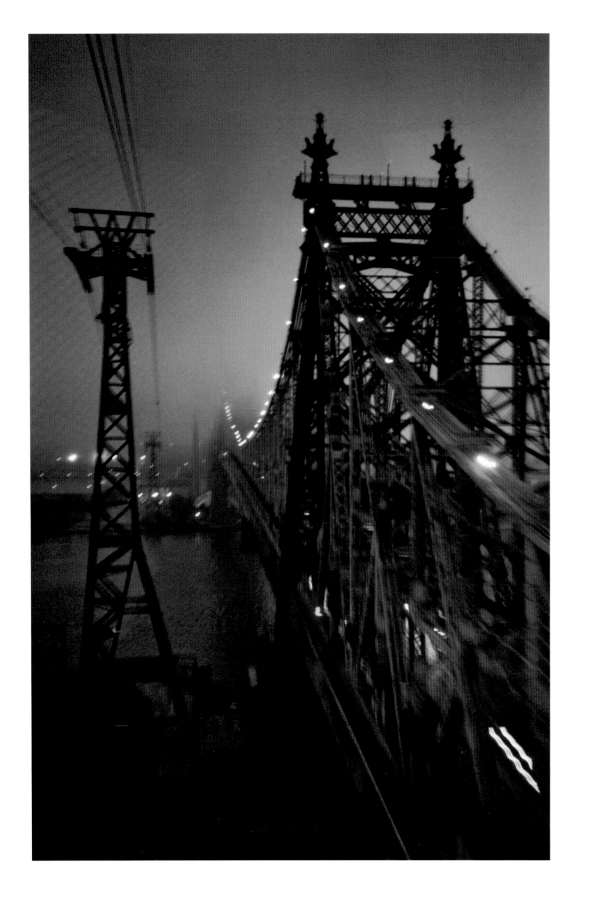

59th Street Bridge

—— Intersection

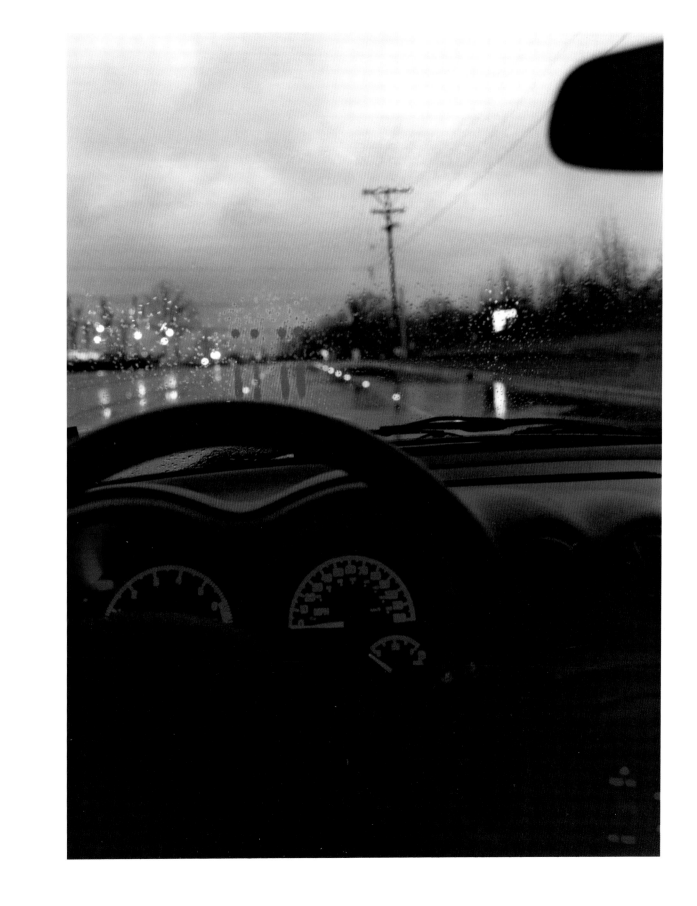

Night/Shift

The New York that I traveled to as a child was a black-and-white city. Those early trips were festivals of arrival and departure, with the family headed for the pier and a sea journey that would inaugurate my parents' sabbatical in Europe. It was as if the city I sped through was the marvelous black-and-white metropolis of early movies, glittering with icons like the Rockefeller Center towers and hinting of shadowed back streets and alleys. I resolved, even then, that I would return to this place I was passing through.

The city I did return to, as a graduate student of photography, was still a film-noir set. It came alive for me at twilight, when the crowds subsided and the streets and buildings seemed to dream their own dreams. In the snow, a skyscraper glittered like a white iceberg. As I looked down from the Empire State Building, the Flatiron became a triangle of blackness, the negative image of an icon. On the roof garden of the Metropolitan Museum of Art, Gaston Lachaise's **Standing Woman (Elevation)** assumed her rightful place as a goddess in the skyline. I still felt the enchantment of my childhood, seeing in black and white.

Of course, I lived my life amid the daytime cacophony of color, the visual complement to the sirens and engines and chatter we all habituate. But, gradually, the more ambiguous, transitional zones of the city began to lure me. My twilight journeys took me to areas where the city was exposed in its unraveling—to building sites in Queens, the broken sidewalks and abandoned buildings under the Brooklyn Bridge. And I began to see these places in color—as if the visual noise of daytime were transforming itself into haunting evening tonalities.

It is often impossible to pinpoint influences. But perhaps the breakthrough color photographs of Stephen Shore, which I had first seen as a graduate student, were having a delayed effect. I was starting to appreciate his marriage of color and vernacular architecture. For me, however, the extra and essential ingredient was twilight itself, transitional zones seen at a transitional time.

Just as twilight is a kind of fluid boundary between daylight and full night, parts of the city are boundaries between past and present, rural and urban, habitation and vacancy. Exploring the border between Brooklyn and Queens one evening, I discovered such a place behind the large neon Pepsi-Cola sign on the East River. For years, I had seen that sign from the Manhattan side as a kind of commercial icon. Now, I was suddenly on a construction site, with bulldozers and backhoes parked for the night. The earth was beautifully plowed, dark brown and scored with tracks, as if on a farm. I was startled into a vision of Manhattan's rural past, ensconced and hidden behind the great red sign.

Another encounter: Walking past a deserted roofless warehouse in Brooklyn's DUMBO neighborhood, I saw motion-sensitive security lights projecting slanting blocks of green and yellow light onto the vacant ground enclosed by the structure. This warehouse and the distant glowing Manhattan Bridge are part of today's New York, but they are also a link to the vanished nineteenth-century commercial city. Even so, such a place is not merely about the contrast between past and present. The city has a way of devouring its past and creating not memorials to a specific time so much as monuments to erasure itself, signs of pure absence and vacancy.

As a flaneur and a voyeur, I like to work unobserved, relying on intuition and staying one step ahead of the wrecking ball. When I discover a site that attracts me, I return to it at dusk and maybe at dawn as well. The first few times, the atmospheric conditions or the artificial lighting may not be quite right. But on a subsequent visit, I may find that a streetlight has gone out, creating the odd shadow that makes the space more angular. I'm delighted by such discrepancies, which are nearly invisible during the daytime: the unexpected and asymmetric, the quietly out of kilter.

I'm a roamer of limbo regions, one of our last frontiers—places that seem unloved and overlooked, cracks in the urban facade. The long exposures—sometimes for up to a minute—required by the low light are my way of giving such places attention and respect. My goal is to allow for enough light to provide shadow detail and texture, but not to overexpose the film and lose detail in the highlights.

I recall Jane Goodall's description of how, shining a flashlight beam at night, she saw a tunnel of color in the monochrome darkness. Goodall's experience inspired me to see how colors flare up near streetlights and how the intense blue of the sky complements the ambers, yellows, and greens of artificial lights. Even with color film, the dusk is luminous. And, during the brief interval of twilight, color and light conspire to approach a higher level of abstraction—symbolized for me by the chromatic beam of Goodall's flashlight.

While I wait for the light and shapes to register themselves on my film, a passerby might accidentally walk in front of my camera. At one time, interlopers would have annoyed me. Recently, however, I have begun to appreciate such visits, welcoming these ghostlike shadowy figures into my photographs. Are they surrogates for me, actors hurrying across a set, or lost friends and relatives coming to people my nocturnal cityscapes? Whoever they are, these figures add to the feeling that something has just happened, that something is about to happen.

Lynn Saville

This work and book have been made possible through the support and participation of many individuals and institutions. I wish to express my sincere gratitude to:

Arthur C. Danto, Elizabeth White, David Blankenship, Yancey Richardson, Phillip S. Block, Paul Kopeikin, David Ferriero, Robert A. Schaefer, Jr., Karen Glynn, Robert Byrd, Kay Kenny, Carla Hanzal, Mark M. Johnson, Michael Panhorst, Alice Novak, Christian Cutler, Christopher T. Ryan, Maria Butler, Deborah Jakubs, Karen Cattan, My Own Color Lab, Pochron Studios, Print Space.

Sam Oppenheim, Ken Fishman, Allyson Lubow, Alberto Blum, Beth Caspar, Gerard Franciosa, Craig McPherson, Tim Tompkins, David Carmona, Tracey Norman, Karen Durbin, Margaret Neill, Mike Stimola, Arthur Freed, Philip Perkis, Philippe Halsman, Lance Keimig, Scott Eiden, Steve Eiden, Tristan Zamula, Josh Strauss, and Jill Waterman.

The New York Foundation for the Arts, The New York State Council for the Arts, The Times Square Alliance.

And most importantly, to my husband, Philip Fried, who makes everything possible.

L.S.

Original exhibition prints 20 x 24 inches
Photographs courtesy of:
Yancey Richardson Gallery, New York, New York
Kopeikin Gallery, Los Angeles, California
Hodges Taylor Gallery, Charlotte, North Carolina
The Photographers' Gallery, London, England
Galerie Baudoin Lebon, Paris, France

Published in the United States by The Monacelli Press a division of Random House, Inc., New York

The Monacelli Press and colophon are trademarks of Random House, Inc.

Library of Congress Control Number: 2009921591

Printed in China

10 9 8 7 6 5 4 3 2 1
First edition

Designed by David Blankenship